UPSTATE
New York

Towns That We Love

Elizabeth J. Cockey & Barton M. Cockey

Bridgeway Books

Upstate New York: Towns That We Love
Published by Bridgeway Books
P.O. Box 80107
Austin, Texas 78758

For more information about our books, please write to us, call 512.478.2028, or visit our website at www.bridgewaybooks.net.

Library of Congress Control Number: 2007943217

ISBN-13: 978-1-934454-19-0
ISBN-10: 1-934454-19-2

Photography by Accent Interactive, Baltimore. www.accentinteractive.net

Lyrics, "Town That I Love" used by permission, © 2004 Bob Warren

10 9 8 7 6 5 4 3 2 1

CONTENTS

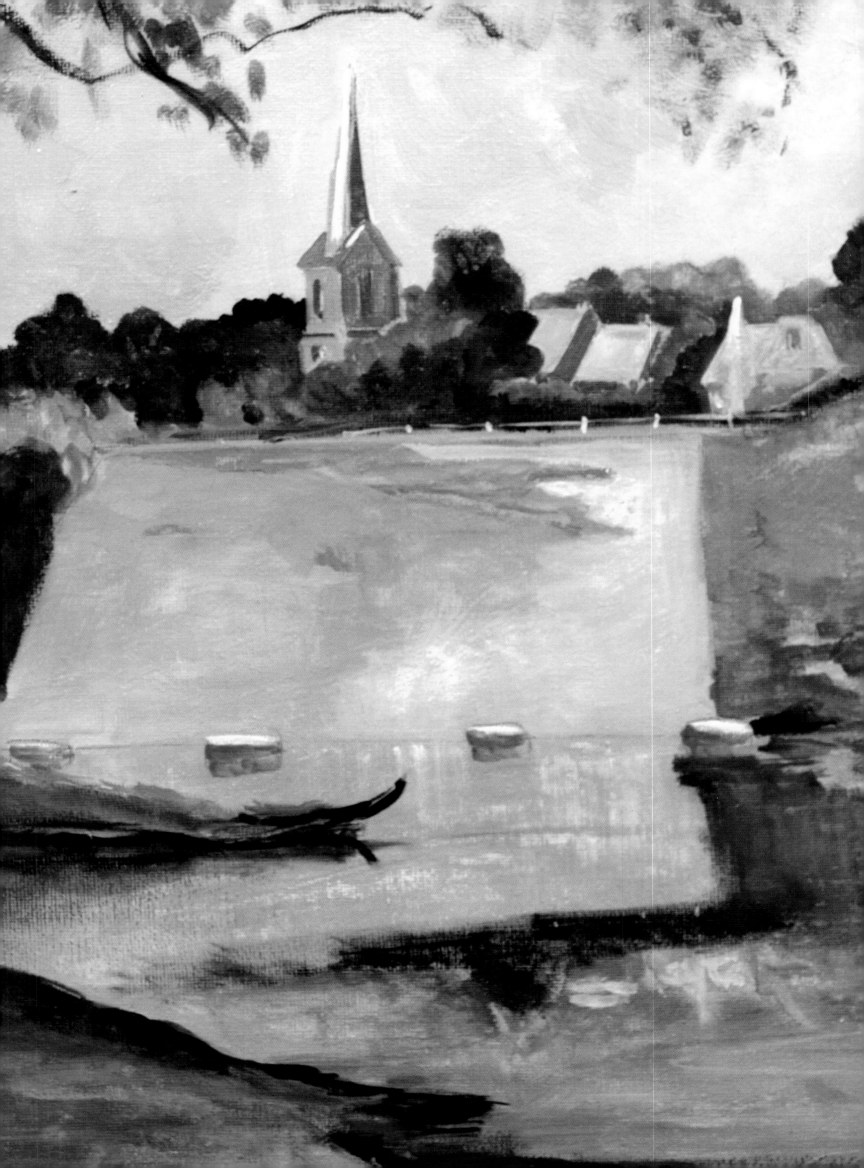

INTRODUCTION

Town That I Love

The first time you climb Thunder Mountain,

You feel like a sparrow in the sky,

Above the treetops, above the steeples, way up

high.

You see the houses of the people,

Always smiling, always kind,

And the sun's light on the river, as it winds...

And like the water always flowing,

The paths we take may lead us far away,

But never too far from knowing,

We all can come home again someday.

Every time I climb Thunder Mountain,

And look at the world from above,

My heart is like that little sparrow,

Looking down on the town that I love.

Lyrics by songwriter, Bob Warren ©2004

Town That I Love
2005; gouache on canvas;
30 x 24 in.

We launched our canoe into the Battenkill River from Rock Street, just above the dam. Looking up, we could see the Baptist and Methodist church steeples in the distance, rising above the town. It was July, and the air was steamy with humidity and filled with anticipation. Viewing this scene firsthand, one is struck by what a wonderful place this would be to live in.

The inspiration for this book is our love for the place where Elizabeth grew up. This collection of paintings is a celebration of the hills, valleys, rivers, history, and architecture of the region around Greenwich, New York. Elizabeth painted the pictures; I wrote the text. The beauty of the countryside speaks for itself, but the friendliness of the people is something that needs to be experienced. As a newcomer to these parts, I feel particularly blessed to have been welcomed into the circle of Elizabeth's friends and family. Bob Warren says that when he interviewed the local school children before writing the songs for *Greenwich: The Musical*, they all told him that their experience of the people is that they are kind and cheerful. That has certainly been my experience as well.

The lyrics to the song "The Town That I Love," reproduced by Bob's kind permission, are especially poignant for Elizabeth and me. Bob Warren and his son sang it at the funeral of Elizabeth's father, Bob Barber.

Dillon's Hill, dubbed "Thunder Mountain" by Bob Barber and his friend John Friday, is on the Barber farm just east of the village. Many parts that were open field and pasture when Elizabeth was a child have since grown up with trees, but the mountain still affords a serene view of the valley of the Battenkill, its houses, and farms. For many years, Elizabeth's father opened the property to the children's outdoor program and shared with them his store of woodlore and camping skills. At eighty, he could climb the trail to the top of the hill with the easy step of the seasoned outdoorsman.

Three years ago, he was diagnosed with advanced tongue cancer. He had a few months to prepare for his death, and one day he remarked in his nasal, up-country voice, "I guess I'm about to find out what it's like on the other side." I said, "I hear it's pretty good over there." He tilted his head and replied, "Well, if it's not, I'm gonna be mad as hell." Wherever he is now, his ashes are scattered on the mountain, and maybe his spirit still looks after the place.

For Elizabeth, Greenwich and its environs have the allure of home and hearth. For me, as a southerner from Baltimore, the region beckons with the excitement of new discoveries. Some aspects of the place have required some explanation. For example, the Village of Greenwich is mostly in the Town of Greenwich but also partly in the Town of Easton, both of

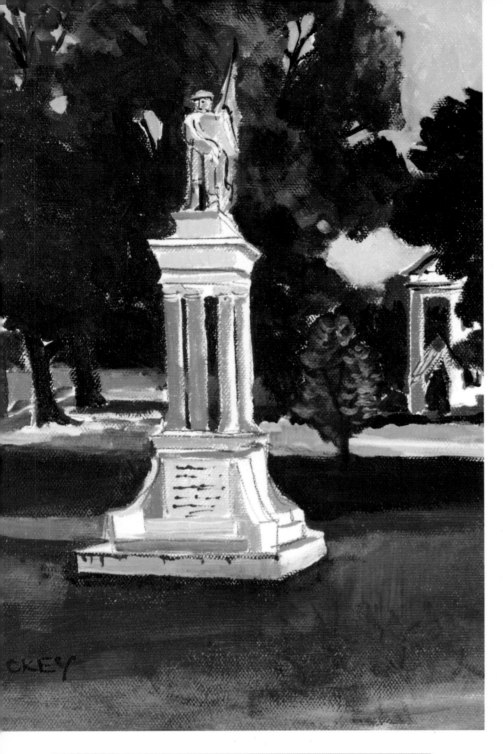

Civil War Monument
2007; gouache on canvas;
9 x 12 in.

The statue was erected and dedicated by the local GAR (Grand Army of the Republic) veterans, many of whom fought in the 123rd Infantry. The monument sits in one of Greenwich's parks on Washington Square in memory of those who fought and died for the Union.

which are in Washington County. Up here, you will see a sign along the road saying "Entering the Town of Such-and-Such," with nary a town in sight. This curiosity becomes easier to understand when you grasp the underlying purpose of an added subdivision: it helps to provide job security for more government officials and regulators. This clever arrangement goes a long way toward justifying the extraordinarily high taxes here, which in turn depress the local economy and help to maintain the slightly down-at-the-heels, quaint, old-time charm of the place. So everything is right as right can be. To avoid confusion, I use the word "town" as a common noun when speaking of a village in the ordinary sense and "Town" with a capital *T* when referring to the official geography.

As someone who grew up in the city and always dreamed of being a farmer with a red tractor, I feel a tinge of envy listening to Elizabeth's stories of farm life. On the north side of the Salem road, at the foot of Thunder Mountain, is Elizabeth's grandmother's house. The frame structure was built by one of her ancestors in the mid-1800s. It was the place of Elizabeth's early childhood. She loved the big, old barn where she sat with her grandfather while he milked the cows and told her stories about his adventures in World War I. She would help herself to her

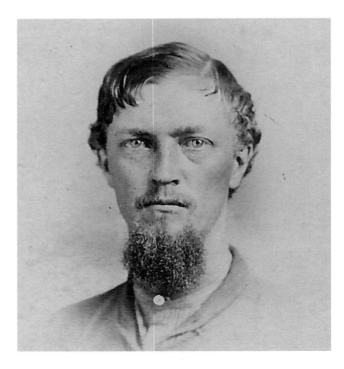

favorite snack, spoonfuls of formula for the baby calves. She wanted a horse more than anything but, at the age of five, settled for riding the calves, which bucked her off. She would get up, dust herself off, and climb onto another calf and ride some more.

As the oldest of three children, Elizabeth was the family activity director and organized theatrical productions, art projects, and expeditions to the "peeper pond" to catch frogs. Her favorite entertainment, then as now, was painting. If paint and a brush were available, Elizabeth found a use for them. Some efforts, like painting a neighbor's wall red or collecting all the baskets from the cemetery and painting them blue, were not well received by her elders; but all the punishments never deterred her from trying a new project. This book is the latest in a long series of such artistic endeavors.

Bottskill Baptist Church
2006; gouache on canvas;
5 x 7 in.

It was early December, and it had snowed. The snow had lightly covered all the houses and trees just before dusk. It was too inviting to sit in the house; we had to go out and take a walk through the town. The first thing we noticed was how the light was filtering down at the end of that day. Across the street from us was the Baptist church, all lit up on the front wall with that beautiful golden light, just like a Christmas card.

Reuben Stewart, Great-Great-Uncle (*Opposite page*)
1864; historic photograph;
3 x 5 in.

Reuben Stewart was my great-great-uncle. Reuben fought in the Civil War with the 123rd Infantry from 1862–1865. He was a prolific writer and wrote many letters home to his sister, Julia, and his father, Nathan Stewart, about the tragedy of war and the beauty of the South. He became engaged through the mail and, upon returning to Greenwich after the war, went on to live a long and successful life.

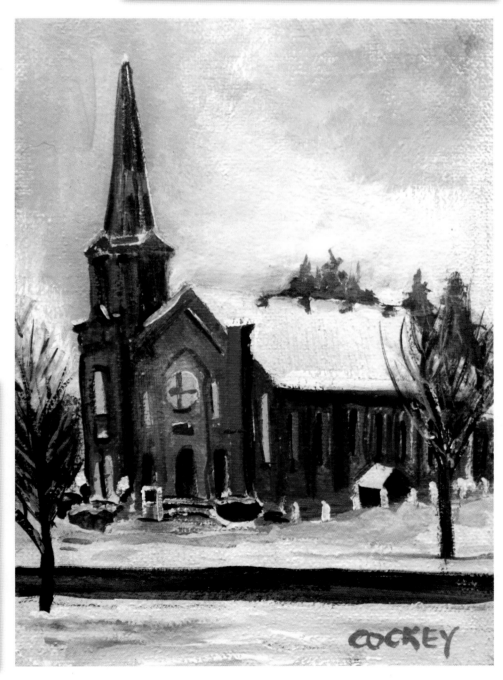

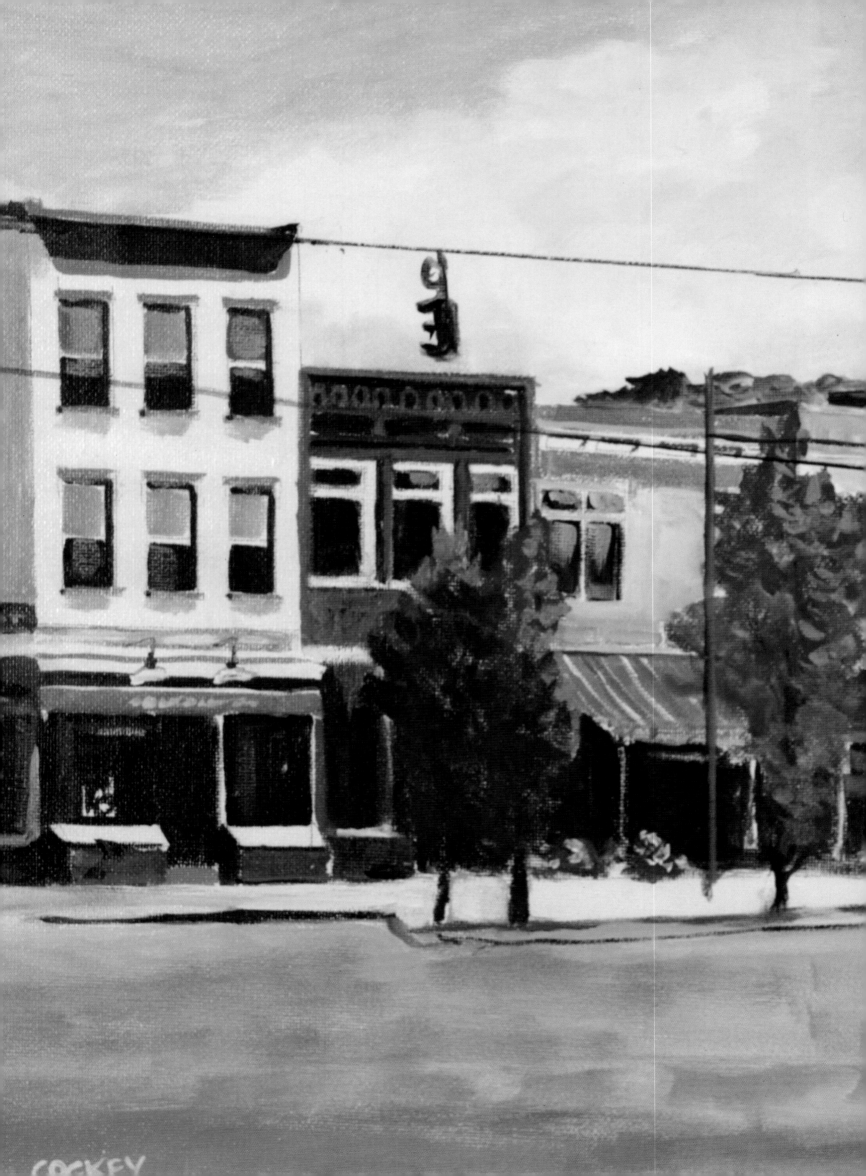

CHAPTER 1
Greenwich

The village of Greenwich is at the heart of our story, not because we love the other towns less but because we love Greenwich more. It is Elizabeth's hometown, and we are blessed to be among people who have been her friends since childhood. Imagine a place where the houses have scarcely changed since the age of Victoria, where the people are kind, generous, and welcoming, and where a chance conversation on the street seldom lasts less than half an hour. That's Greenwich.

Hugging the shore of the Battenkill River, Greenwich started out as a mill town. In 1804, Job Whipple dammed the swift-running waters a short way from their final falls into the Hudson. The first mills sawed wood and ground grain. Whipple had come from Cumberland Hill, Rhode Island, obtaining title to the present site of the village in 1781. He bought the land from a Mr. Carbine of Albany, who had already built a dam, a sawmill, and a store. A hard-working, devout Quaker, Whipple was well regarded as a man of integrity and served as justice of the peace, holding court sessions in his home. Back then, the little hamlet was called Whipple City. The name changed to Union Village in 1809, reputedly in a fit of goodwill and harmony on the part of the villagers over the uniting of people from two Towns (Greenwich and Easton). Another theory I have heard is that the renaming was part of the tail end of the general fervor over the establishment of the Federal Union. The name is preserved by Judy Flagg's Union Village Shop on Main Street.

Main Street, Greenwich
2007; gouache on canvas;
16 x 24 in.

Many of the historic buildings on Main Street have been restored or revitalized. Today there are a delightful variety of shops and stores to peruse: a natural foods market, a flower shop, antiques and collectibles, and numerous gift shops. Union Village Ltd. is one store that stocks a unique collection of Colonial decor and crafts such as cloth floor rugs, stenciled design patterns, and handmade pottery and furniture. Further along the street, you can find historic memorabilia in other local shops featuring antiques from the late 1700s.

The name of Greenwich was adopted later still, in 1867. Perhaps reflecting a more general loss of local autonomy, the present name is said to have been assigned by the post office. Straight-talking Yankees that they are, the folks here pronounce the name exactly as it is spelled. Like Thames Street in Baltimore (rhymes with aims), this kind of honest pronunciation, uncorrupted by the German accent of King George I, is as bracing as the cool water of the Battenkill River where the children swim on hot summer days at a bathing beach bought by the town from the Michael Brock farm in 1948.

Called Ondawa by the Indians, the Battenkill rises in Dorset, Vermont, and flows twenty miles through Vermont before entering New York. It is said to be one of the best trout streams in the country. Once filthy with the careless effluent of paper mills, the stream is again pristine.

One brilliant August afternoon, Elizabeth and I launched a canoe at the park on Rock Street and paddled upstream to the stony shallows above the bathing beach, at the foot of Thunder Mountain. I waded out toward the middle and soon

The Academy
2006; gouache on canvas;
11 x 14 in.

The Village of Greenwich offices are housed in the historic Academy building, which was previously a private school in the 1800s. The building is listed on the register for historic buildings and is right down the tree-lined street from where we live. Today the Academy is not just used for the village offices, but is also used by the local fire department that parks its fire trucks out back. Barton and I "snuck" upstairs once and were awestruck by a huge ballroom that took up the entire second floor and was complete with a stage for theatrical productions.

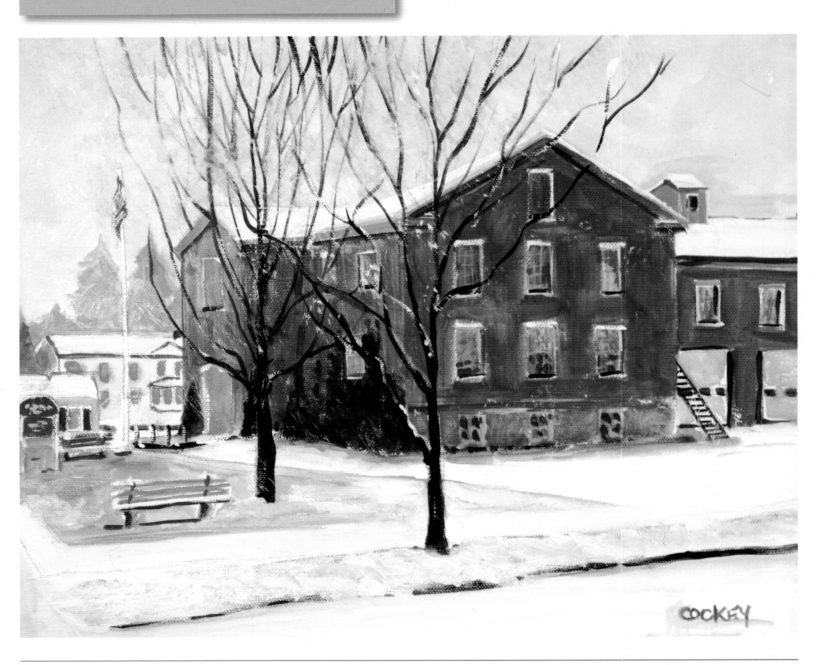

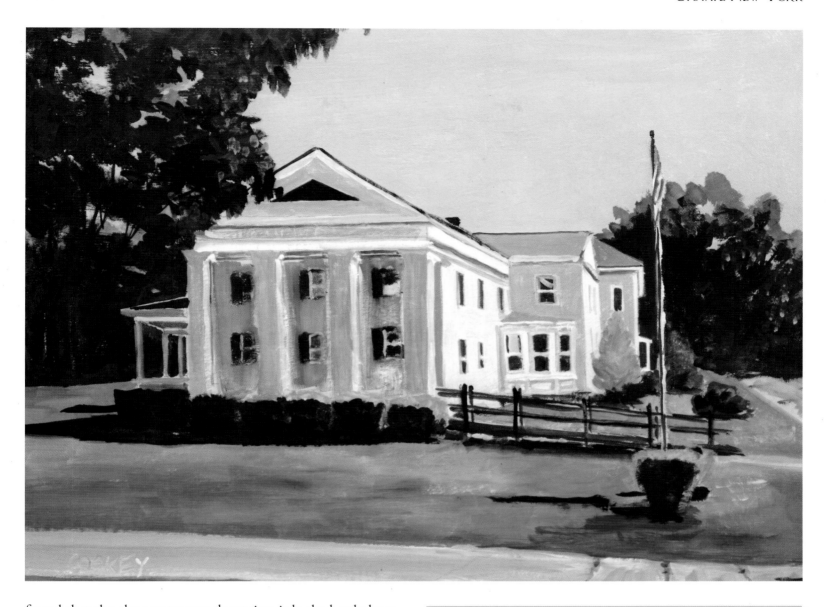

Town Offices
2006; gouache on canvas;
11 x 14 in.

Next door to the Village of Greenwich offices is another historic building, which is now the location for the Town of Greenwich offices. This was originally confusing to us, but we eventually learned the protocol for local governing bodies in upstate New York: we live in Washington County, in the Township of Greenwich and in the Village of Greenwich. Believe it or not, there is a portion of the Town of Easton that also lies in the Village of Greenwich. (I still haven't figured out where they pay their taxes!)

found that the clear water was deceptive; it looked only knee-deep, but I was up to my waist. Soon I was treading water. Looking down, I could see my feet dangling above the round rocks on the bottom. The only sounds were birdsong and the gurgling of water. I regained my footing and flipped over a flat piece of shale with my toe. The underside was crusted with caddis fly larvae. A crayfish darted out, and his flight took him under the nose of a smallmouth bass hanging motionless in five feet of water, facing upstream. In one continuous motion, the bass sucked the crayfish into his mouth and spit out the shell, which flowed past him like a discarded wrapper thrown from a car window.

The sun was nearing the level of the western treetops as we paddled back to the landing. The wind picked up, and if we had slackened our paddling, we'd have been blown back up the river. Ahead of us, the sun cast a million diamonds on the ripples. Also ahead and to our right were the steeples of the Baptist and Methodist churches. From this vantage point at least, it appeared that God was in his kingdom, and all was right with the world.

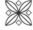

Up close, it is even more evident that Greenwich was built according to the Maker's specifications, with plenty of opportunities for patience, charity, repentance, and par-

don. The full array of human strength, frailty, wisdom, and folly is on view. Everyone here seems to know everyone else's business and usually has an opinion on it, customarily introduced by the disclaimer, "It's none of my business, but…" In the big city, you may successfully appear to be what you are not. In a village like Greenwich, everyone figures out what manner of person you are and how your character fits into the general pattern of your family: "Well, what do you expect? She's a Jenkins"; "I just knew he'd get

right on it. Those Marples are as quick as a whip"; or "Y' know, that side of the family is either crazy or brilliant, not much in between. The other side never amounted to anything."

The upshot of all this multigenerational knowledge among neighbors is a good-humored and kindly acceptance of human imperfection. Greenwichers cherish their colorful "characters." (Note that here, as in the preceding paragraph, the names have been changed to avoid offense.)

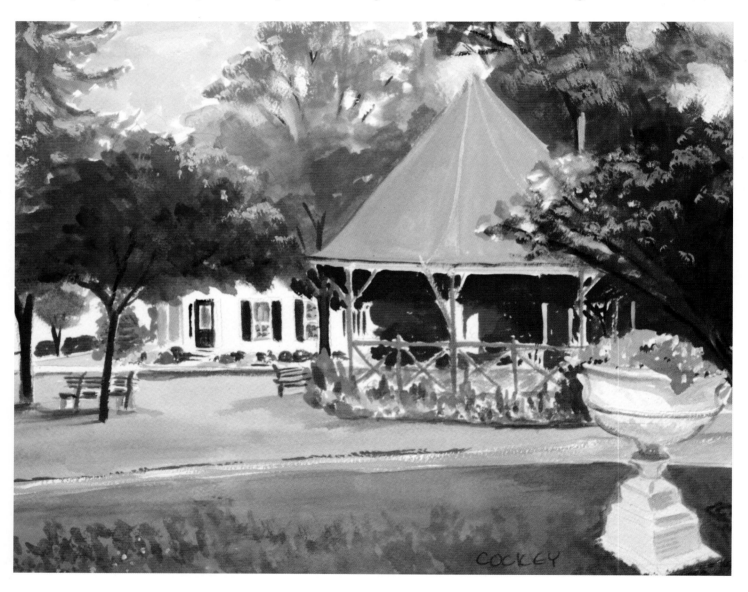

Mowry Park
2006; watercolor;
16 x 20 in.

Located in the center of town, Mowry Park is a delightful place to visit any time of year. In the summer months, the Village of Greenwich hosts "Whipple City Days" (the village was originally named Whipple City and then Union Village before becoming Greenwich) and many other outdoor events. The park is a gathering place for anyone who wants to picnic, romp, or listen to local musicians at night.

There was, for instance, Jonas Brown, who always walked around the village in his white, sleeveless undershirt, even when the temperature fell below zero. His tolerance for the cold was legendary. In the winter, he liked to sleep in a screened porch on the second-floor of his house with only a sheet over him. In the morning, he would wake up and shake the snow off. One wintry evening when a television news team was filming an interview about the ghost in the Episcopal rectory, the

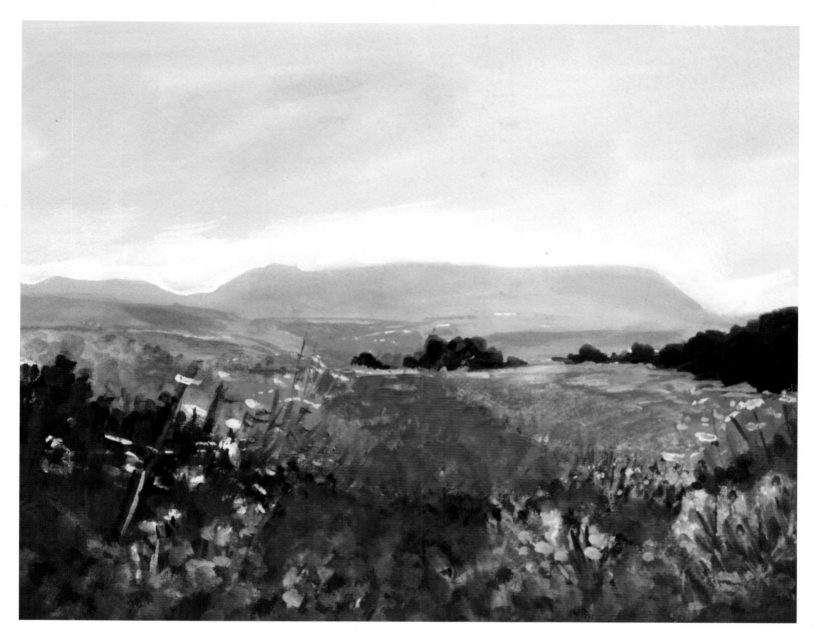

reporter's eyes opened wide, and his mouth dropped open. The cameraman lost his balance. Viewers were convinced that the ghost had come out, until the apparition proved to be only old Jonas in his undershirt.

Then there was Ron Wilson; he liked to travel. Most days, you could find him out on the road, hitchhiking. Not being too particular about where he went, he would stand on Route 29 with one thumb pointed east and the other pointed west. One time someone stopped to give him a lift at the bridge over the Champlain Canal. "Where you headed?" the driver asked. Ron gave his standard, noncommittal answer, "Over there." Just across the canal bridge, there was a tavern. "You can let me out here," said Ron. Nobody ever asked him why he didn't just walk across the bridge. They knew that wouldn't have been his style.

Every family has one or more "characters" in it, and some families are so well stocked that they have to lend some out

Thunder Mountain
2005; watercolor;
16 x 20 in.

Thunder Mountain is the highest hill around. It is located on my family's farm, just outside of Greenwich. Named and christened by my father and his best friend, John Friday, it became a destination for many local residents who were always welcome to climb the hill. From the top, you can see for miles into Vermont on one side and as far as Saratoga Springs on the other side. From the vantage point in the painting, I could see Willard Mountain, which is now a ski resort, on the other end of the valley.

from time to time to other families or to correctional facilities. (The characters in our family have been omitted because of space limitations.) No matter how accomplished, bright, or important you are, when you can look out your window and see Uncle Ron bidirectionally hitchhiking down Main

Winter on the Kill
2005; gouache on canvas;
24 x 30 in.
This view of the Battenkill River is due east of Greenwich on Interstate Route 29; the river and the interstate run side by side, heading toward Salem and eventually toward Vermont. The painting not only shows the river winding along the roadside, but also the wonderful, lumpy hills that get lumpier as you reach the Vermont border.

Street, you are likely to take a milder view of other people's faults. Still, it seems that eccentricity today, like so many other things, does not rise to the standards of yore. Jon Stevens says, "The present crop of auslanders has little firsthand experience with the characters. The real prizes are gone."

The names of the early families that founded and sustained the village are still on the map. A lovely little park with a gazebo is named after William Mowry—protégé, business partner, and son-in-law of Job Whipple. In 1804, Mowry came from Rhode Island and set up the first cotton factory in the state of New York. After a bit of industrial espionage in England, he incorporated the latest spinning technology in his plant. Women from the surrounding countryside wove the yarn into cloth.

Eddy Street is named for Walden Eddy, who ran a foundry and plow works just across the Battenkill in the Town of Easton. Eddy was born in South Corinth in Saratoga County in 1807. He started work as a carpenter at the age of twenty but soon decided to work with metal instead of wood. He entered the foundry business in Corinth in 1832 and moved to Greenwich in 1835. His company, Eddy Plow, developed a reputation for quality and honesty that served both the firm and the village well for more than a century. Walden Eddy

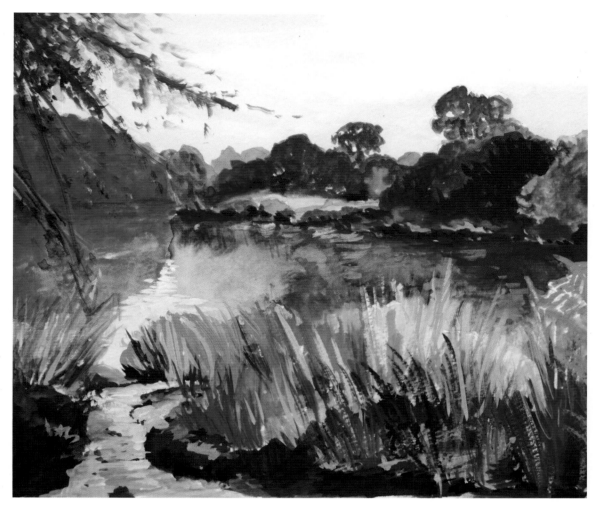

Summer on the Kill
2004; watercolor;
9 x 12 in.

We waded across the Battenkill River one day in August, searching for round river rocks, and we came across this little stream that flowed out of the hills from the other side. Everywhere that we looked and everything in the landscape that we could see was green—a thousand shades of green.

died at the age of eighty-six, honored by the community as a good and generous man whose business brought prosperity to the town. His company outlasted him and finally closed its doors in 1952.

Corliss Avenue commemorates a distinguished physician. Dr. Hiram Corliss was born in Easton in 1793 and began his medical practice there before moving to Union Village in 1825.

A man of strong opinions, he

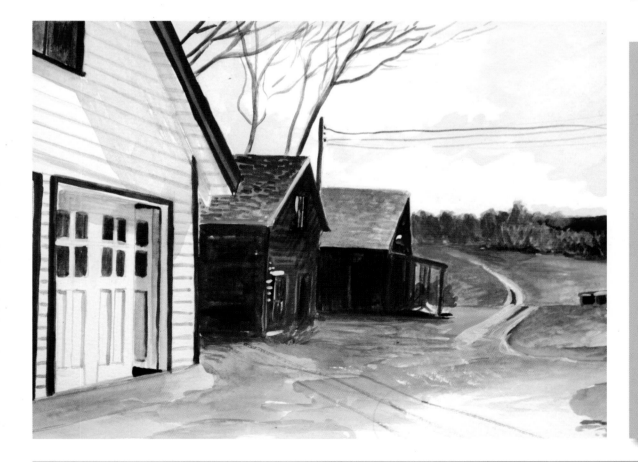

Barns Behind Gramma's House
2004; watercolor;
9 x 12 in.

The sheds and the white garage behind my grandparent's house are filled with a plethora of objects: antique farm equipment, an upright piano, shelves of books, a 1932 Ford Tractor, paintings, and bric-a-brac left over from earlier times. Many outbuildings on other old farms in the area store similar kinds of things, all left over from an era when farming was the mainstay.

became a noted abolitionist and also shared with the public his views on "suffering Ireland," the Order of Odd Fellows, "demon rum," and homeopathic medicine. His sharp remarks on homeopathy, delivered before the Washington County Medical Society in 1847, are quoted in Grant J. Tefft's *The Story of Union Village*:

> Verily it may be said that if homeopathy is true, that if a grain of charcoal should fall into Lake Erie, and its mighty waters be shaken by a gentle breeze, a single drop of this medicated water would produce 460 characteristic symptoms of disease in a healthy person, and if administered to the sick, the effect of a single dose would last thirty or forty days…If doctors can be such fools as to attempt the cure of real diseases by Homeopathic remedies—and if patients can be such fools as to trust their bodies in such hands—why then, they are fools on both sides.[1]

The temperance crusade divided the community in those days, as Dr. Corliss and others, including John Curtis, the editor of the Washington Journal, bent their efforts to the prohibition of alcoholic beverages. Tempers ran high, and nocturnal vandals broke windows in Dr. Corliss's store and blackened the fronts of buildings.

Corliss was also active in the radical Eastern New York Anti-Slavery Society and was elected president of that organization in 1842. Among its members were the famous "slave-stealers" William L. Chapin, Rev. Charles T. Torrey, and Rev. Abel Brown. These men went into slave states and brought fugitive slaves north to freedom, and Union City became a stop on the Underground Railroad. Dr. Corliss and William H. Mowry, son of the mill-owner William Mowry, had earlier founded an abolitionist church, the Orthodox Congregational Free Church, in 1837. After the passage of the Fugitive Slave Law in 1850, Corliss became president of a vigilance committee whose purpose was to thwart slave catchers. It is said that no slave was ever caught after traveling as far north as Union City.

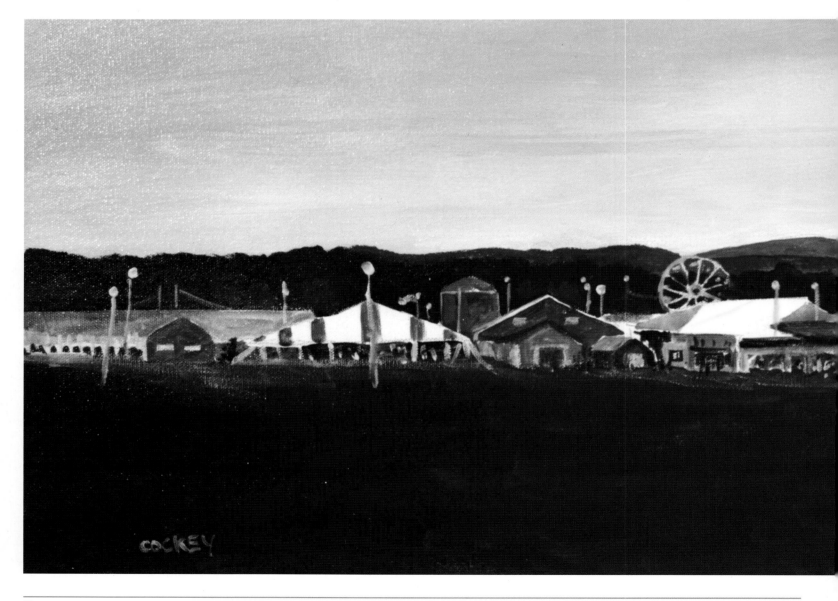

Dr. Corliss's abolitionism appears to have been less controversial than his support of prohibition. The last slave was sold in the village in 1800, the last bottle of ardent spirits rather more recently.

These conflicts were not the first that these green hills had witnessed. The Great War Trail ran along the Hudson, on the western border of the Town. Raiding parties used the trail long before the French incited the Indians against the early English settlers on the frontier. Only after the end of the French and Indian War in 1761 was the neighborhood reasonably safe for settlement. Thereafter, an intrepid few, most notably Judge Nathan Tefft, began to establish farms. Tefft came from Rhode Island and settled in what is now Middle Falls. His descendants are still among the village's distinguished citizens.

Farmers and factory workers alike were drawn into the hideous slaughter of the Civil War, and a monument to the 123rd New York Regiment stands in the middle of the village. There is scarcely a family in the Town of Greenwich that does not

number veterans of that conflict among its forebears. Elizabeth's family has preserved letters written from the front by her great-great-uncle Reuben Stewart. He was a fairly prolific writer, and his letters reveal the privations of army life as well as the allure of the exotic culture of the South, with its variety of vegetables and its fascinating dark-skinned women. He expressed his anxiety that all the eligible young ladies in town might be married off before he returned home, and he longed for the sight of the "dear old Bottskill Baptist Church." Unable to propose to his love in person, he got engaged by mail. Upon his safe return from the

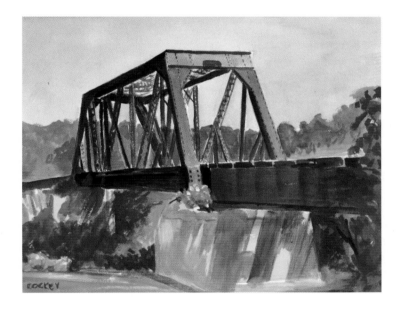

Trestle Bridge
2003; watercolor;
11 x 14 in.

The old trestle bridge crosses over the Battenkill on the way to Cambridge from Greenwich. Back when I was a kid, some of my more adventurous friends would dare one another to jump off the top into the water below. It was in use until fairly recently.

Washington County Fair
2007; gouache on canvas;
9 x 24 in.

Held at the end of August, the Washington County Fair is one of the highlights of the year for those who live nearby. And everyone who comes to the fair is there to share news or gossip, ride the Ferris wheel, view the 4-H kids' farm animals and craft projects, and taste the local honey. In the background, you can see the gentle Vermont mountains against the foothills as the sun goes down. If you were standing at the fair right in this moment, you might also hear the soft sounds of cows moving around, settling down for the night, or chickens scratching in their pens.

Grand View
2006; gouache on canvas;
16 x 24 in.

Built circa 1830 by my great-great-grandfather, Nathan Stewart, this house became the family homestead and was a working farm until the barns burned in 1956. I lived with my parents on one side of the house, and my grandparents lived on the other side until I was five years old. The house sits back from the highway just outside of Greenwich on Route 29. The view from the house was called the "Grand View" because of the remarkable vista of the Battenkill River leading into town.

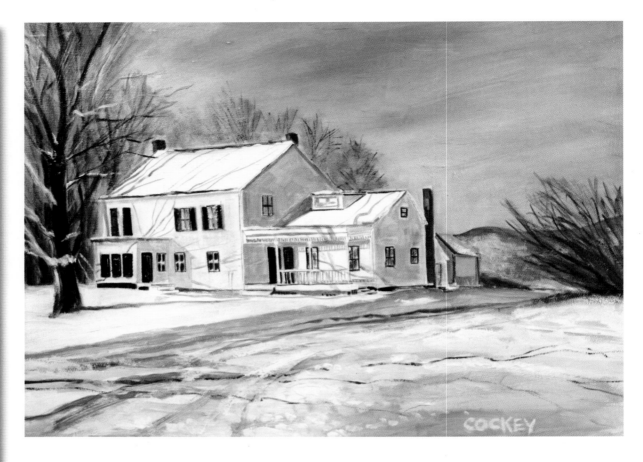

war, he lost no time in tying the matrimonial knot and went on to father fourteen children.

Another mill operator, Daniel Anthony, moved here from Massachusetts in 1826. The Quakers had split in that same year over the divinity of Christ, and Anthony sided with the

D.D. Haskel House
2007; watercolor;
16 x 20 in.

D.D. Haskel was a son-in-law of William Mowry and lived in this house on Church Street. Several other houses up and down the street were also owned by the Mowry family. Today it is a stunning place, especially at Christmastime when it is lavishly decorated and lit up for the holidays.

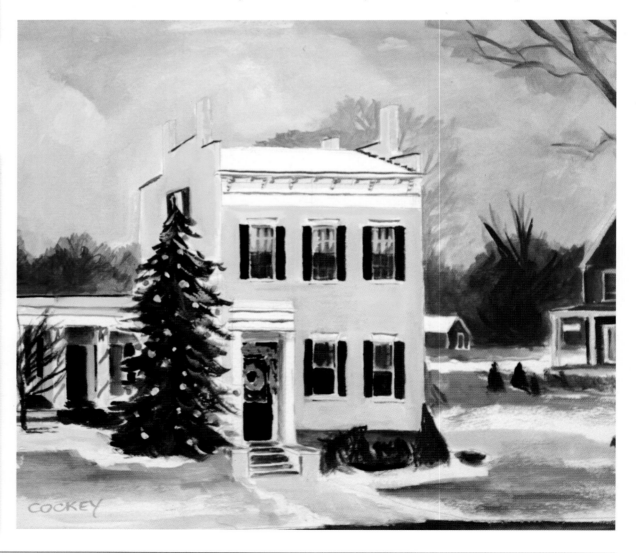

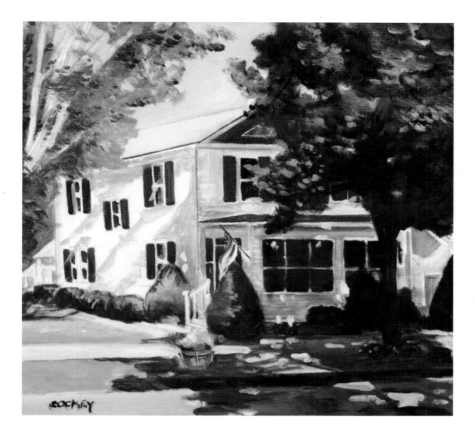

liberal faction. His daughter, Susan B. Anthony, was six years old when he moved to Battenville to run a cotton mill there. Mostly home-schooled and encouraged to think for herself, Susan was to rise to national renown as an advocate of women's suffrage. When the Panic of 1837 left them destitute, the Anthonys sold everything they had and moved to a

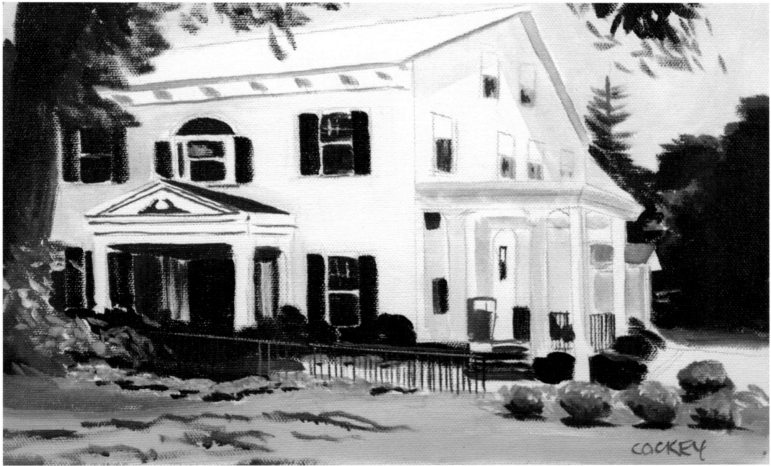

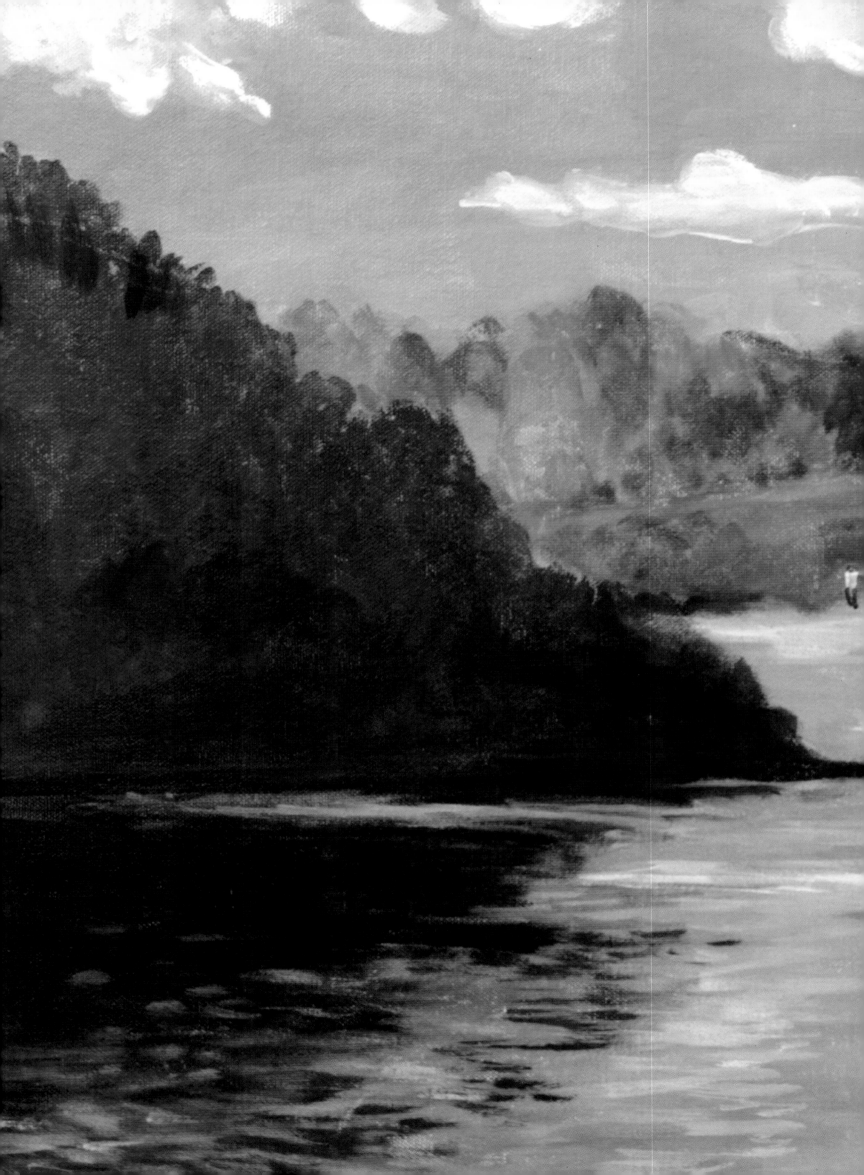

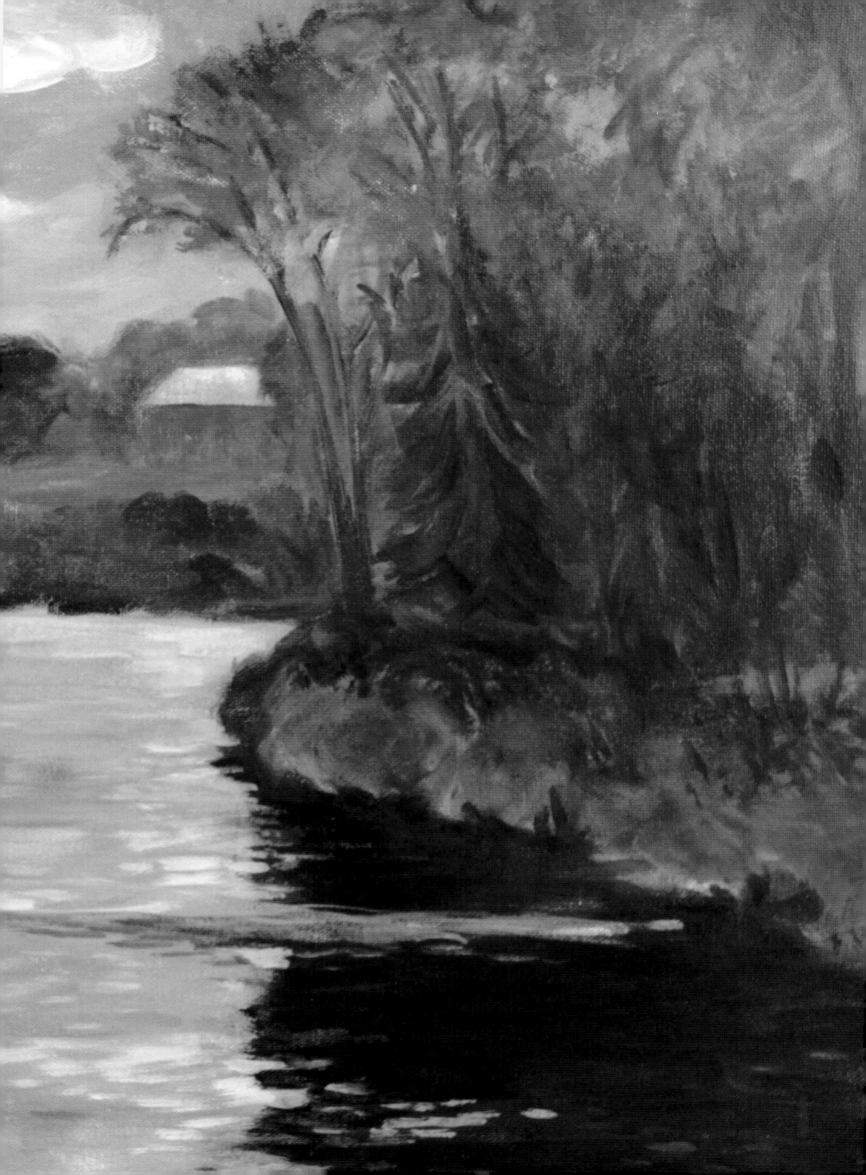

house in Hardscrabble, where Susan taught school to help pay the family's bills. Mr. Anthony was a stern, opinionated man who did not permit his children such juvenile diversions as toys, games, or music, which he believed interfered with the "inner light." A man with such an outlook must be constantly choosing the lesser (or with so many to choose from, the least) of possible evils. One such choice was to allow the local teenagers to hold dances in the large room on the third floor of his big frame house by the river so that they could be properly supervised and kept away from drinking establishments. For his efforts, he was "read out of meeting" by the Quakers. The original Anthony house in Battenville on the Salem road (Route 29) is still standing and was recently acquired by the state. The frame house in Hardscrabble, last occupied by the Dutcher family, was torn down by Hollingsworth and Vose in 1965; but our friends George Perkins and Charlie Tracy remember playing in the building when they were children. The dark, cavernous dance hall in the attic was their clubhouse in inclement weather, and their password was, "Who dares go up these stairs alone?" (Not many did.) Hardscrabble itself is now called Center Falls because Anthony had the name changed when he was postmaster.

The little village of Greenwich has produced other famous people: Grandma Moses was born near here in the Town of Easton but is more associated with the Town of Hoosick, where she lived when she took up painting.

Kim Gannon is best known for writing the song "I'll be Home for Christmas." The children loved to visit his house on Halloween because he gave them the best treats in town; each trick-or-treater got a big gumdrop and a nickel. He had built the back part of his house on Prospect Street around a living tree, and Elizabeth and her friends were fascinated to see this

marvel of a tree growing right up through the middle of his family room.

The country singer Hal Ketchum emigrated from Greenwich. The song he made popular, "Small Town on a Saturday Night," has been presented as an evocation of growing up in Greenwich, but shooting out the light was not done in this village. They did that in Argyle. None of his contemporaries that I have interviewed recall howling at the moon, but you have to wonder how much anyone in that condition would remember. Sneaking into the movie theater at the White Swan and making out at the Beagle Club may not have been as song-worthy but provided excellent entertainment at the time. I wish I could have been there.

Bob Warren is a highly talented musician and songwriter who combines heartfelt melodies and thoughtful lyrics. He wrote a musical play about Greenwich and has recently completed a series of compositions about Susan B. Anthony. Many of his songs, including "The Silver Fox," a very touching ballad about his father, can be downloaded from the Internet. Bob's brother Don Warren is also a musician and has built a fine reputation as a guitar maker.

A fondness for live and original country music is a delightful feature of Greenwich, and we were privileged to attend a block party where the band included Bob Warren's son, Kevin, and Bob Wright's son, David. The next generation is keeping the beat going. While we listened to the music, the youngsters were playing at horseshoes. They were also playing a game they say is called "Texas horseshoes," which involves throwing large metal washers through holes in a box. Some of the spectators were doubtful that anyone would call it that in Texas.

As we ate and drank our fill and chatted with friends about the crazy things everybody did as youngsters, we found that the conversation always returned to the river that was the village's reason for being. They talked about spring melts when blocks of ice the size of a door would burst out of the river and hot summer days when they would dare each other to jump off the trestle or climb down the treacherous rocks to swim in the "devil's pool" below the high falls. George Perkins asked

Looking Up the Kill (*Previous page*)
2005; gouache on canvas;
24 x 30 in.

It was a lovely fall day in late September, and we were out in our canoe paddling back to town. We could just make out two people way up the river fishing along the bank. The light was golden, and the trees had just started to turn color, yet the temperature was still warm with the last rays of summer. That particular day it was difficult to imagine being anywhere else except on the river.

whether we have ever seen the high falls of the Battenkill from the viewing platforms. When we replied that we hadn't, he insisted that we go immediately.

As the sun was starting to set, we followed George down the trail through the woods. We were the only ones in this magical place where the river drops 130 feet over a series of rock ledges, the "Dionondahowa Falls." A turbine in an adjacent dam has generated electrical power since 1900 when the electricity ran the first trolleys between Greenwich and Schuylerville. A rail trestle that once spanned the river here must have provided quite a view. The gorge below the falls is almost inaccessible, with steep walls of shale. From where we stood, the stream ran straight northward, away from us, before its last, westward turn toward the Hudson. The golden light of the setting sun fell on a red brick building at that far turn, an old mill that looked like a distant castle. Yes, it's all about the river.

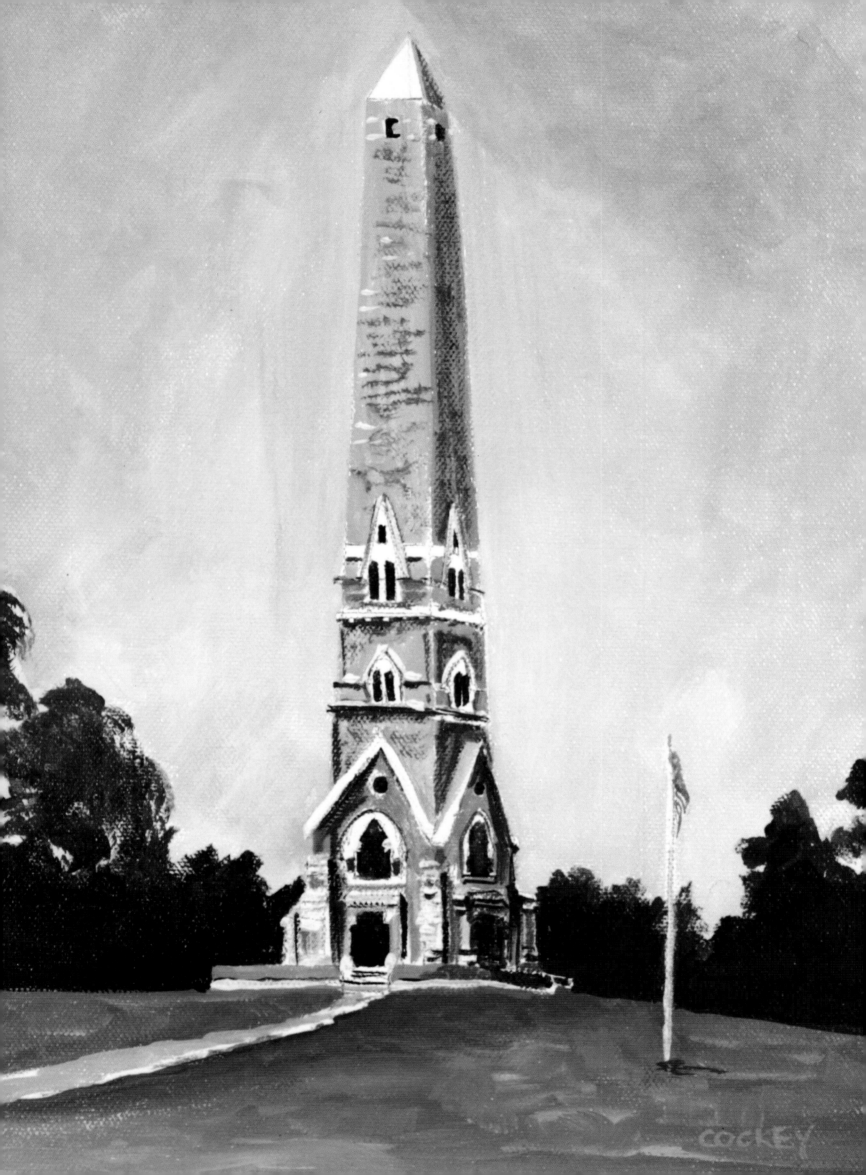

CHAPTER 2
Schuylerville

For those who are under the impression that the Battle of Saratoga took place at the racetrack, it will come as a surprise that this decisive clash occurred just south of Schuylerville. Of course, in those days, Schuylerville was called Saratoga, and the present-day city of Saratoga Springs was wilderness.

This little town on the Hudson River is named after General Philip Schuyler. A fourth-generation American born in Albany in 1733, Philip Schuyler was a wealthy man and in every way a gentleman. He had a mansion, lands, and mills along the Hudson here and a fine house in Albany. At the age of forty-three, he cut a fine figure in his uniform, but his military resume seems rather thin to support his appointment as commander of the Northern Department in 1775. He had served as a captain in the French and Indian War and later as a deputy-commissary with the rank of major. Well connected and energetic, he lent his political support to Governor Henry Moore, who made him a colonel of militia.

Planning the invasion of Canada became his first project in his new command. In 1775, he set out on the campaign with about seventeen hundred militiamen but had to turn back because of an attack of gout. He sent the ill-fated expedition on without him, under the command of Richard Montgomery. During the winter of 1775–1776, he busied himself with the supply of Montgomery's forces and the suppression of British loyalists and their Indian partisans in the Mohawk Valley. The sad, smallpox-ridden remnant of the invasion force retreated to Crown Point without Montgomery, who had been killed in the assault on Quebec City. The new commander, General John Sullivan, was replaced by General Horatio Gates.

An arrogant little man, Gates immediately began scheming to take over the Northern Department command from Schuyler. Two events supported his position as he brought his case before Congress. First, Schuyler had withdrawn the army from Crown Point, a reasonable move but one that left him open to the charge of timidity. Second, the garrison at Ticonderoga had been lost with all its supplies. Proud of the bold stroke of Ethan Allen and the Green Mountain Boys, who had captured the fort in 1775, the American rebels were outraged when they heard that Burgoyne's men had recaptured it without firing a shot. As usual, the blame went up the chain of command.

To cap off his difficulties, Schuyler had been active before the war in the border dispute arising from a series of grants by provincial governor Benning Wentworth of New Hampshire between 1749 and 1764. The occupants of the townships carved out of territory claimed by both New York and New Hampshire were rough, hard-living frontiersmen who had just renamed their region the Republic of Vermont (from the French *vert mont*, meaning "green mountain") on July 8, 1777. The dispute between them and the New York patricians who claimed jurisdiction over their land grants was a sore point in their relations with Philip Schuyler. Some of the proto-Vermonters were beginning to wander off, and Gates claimed, probably correctly, that he would be a more popular leader for this demotic crew.

So it was that in August of 1777, almost on the eve of the battle at his hometown, Schuyler was removed from command and superseded by Gates. Thus, insult was added to the injury Schuyler would suffer with the destruction of his farm. A court martial, convened in 1778 at Schuyler's request, would later clear him of all the charges Gates had made against him.

It is a measure of General Schuyler's character that he conducted himself graciously throughout this difficult time, and he showed kindness to his defeated foe even as the dust had barely settled on the ruins of his mansion. When Burgoyne apologized for leveling the house, Schuyler replied, "Fortunes of war. Say no more about it." His apparent equanimity seems

Saratoga Battle Monument
2007; gouache on canvas;
9 x 12 in.

Built in 1877, the monument was built to commemorate English General John Burgoyne's surrender to American General Horatio Gates a hundred years earlier. The monument is now open to the public from Memorial Day through Labor Day, and it is possible to climb to the top for an incredible view of the Upper Hudson River Valley.

strange until you consider that thirty-two years earlier the French and Indians had destroyed the entire village with its mills and houses and killed thirty people, including Schuyler's father. He may have considered himself to have gotten off lightly this time.

A remarkable account of the battle was written by Frederika Charlotte Louise, Baroness Riedesel, who traveled with Burgoyne's army in the company of her husband, who commanded the German troops. (Most of the Germans in this engagement were actually not Hessians. They came from Brunswick and would more aptly be termed Braunschweigers.) The baroness recorded being met at her calash by a handsome man who, with manly tears glinting in his eyes, helped her from the vehicle and hugged and kissed her children, allaying their fears. The good-looking man proved to be none other than General Schuyler, who then invited her and her children to join him in his tent for a "frugal dinner" of smoked tongues, steak, potatoes, and bread and butter.

Weary, no doubt, of the amateurish backstabbing of the army, Schuyler retired from military service in 1779 to join the professional backstabbers in the Continental Congress. Even away from the battlefront, he was never safe from the enemy. On February 20, 1781, a man named Waltermeyer, with a gang of cutthroats, burst into the Schuyler house in Albany and overpowered the guards. The family ran upstairs,

Ferry & Broad Streets in Schuylerville

2007; gouache on canvas;
9 x 12 in.

Just after crossing over the Hudson River, traveling west on Route 29, you will come into the town of Schuylerville. This charming little town begins at the junction where Ferry Street joins with Broad Street. Driving along Broad Street, it is heartening to see the revitalization and restoration of historic buildings along with new restaurants, gift shops, a bed-and-breakfast, and a small motel. On the way out of town, you can see that the old high school has been restored too. Today it houses several local businesses that serve the community.

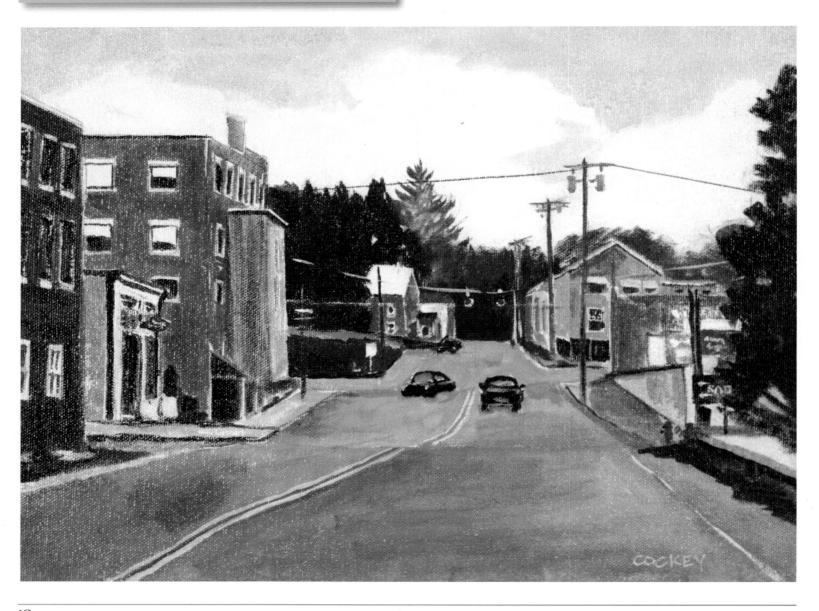

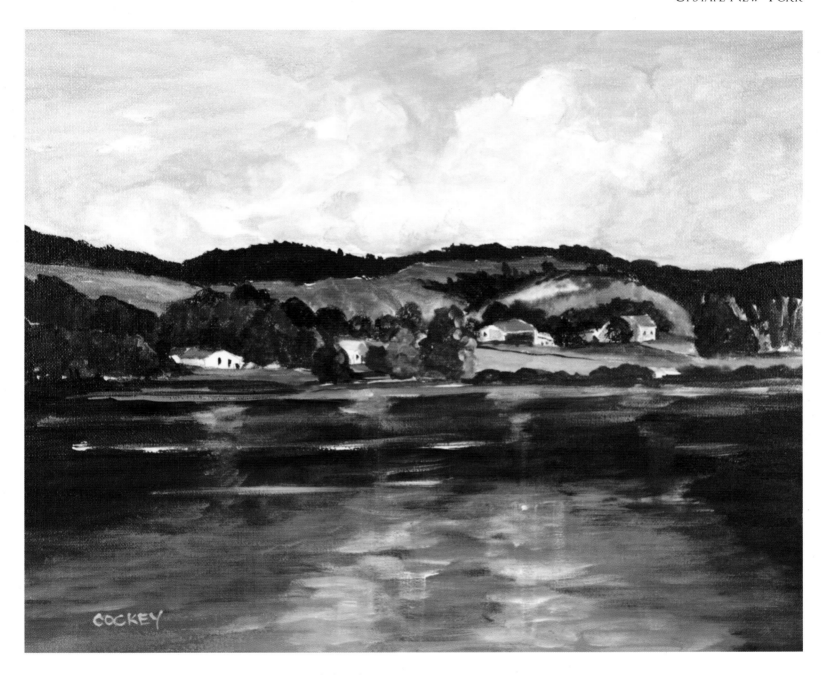

Going Down the River
2007; gouache on canvas;
16 x 20 in.

Our friend George Perkins took us for a boat ride down the Hudson late one afternoon in July. What a trip it was! We were able to look up at the Saratoga Battlefield as we went by, and we wondered if the British had also looked up from that vantage point as they made their way down from Lake Champlain over two hundred years ago.

snatching up their weapons as they ran. A quick head count (Schuyler had eleven children) disclosed that the baby Catrina had been left sleeping in her cradle in the basement. Margarita, then twenty-one, rushed down to retrieve her baby sister. On her way back up, one of the ruffians threw a tomahawk, narrowly missing her. Waltermeyer, thinking her to be a servant, asked where her master was. "Gone to alarm the town," she answered. Hearing her reply, Schuyler then threw open a window and shouted as if urging forward a party of rescuers. The gang ran away, carrying off the three guards and some of the silverware.

When peace came, Schuyler worked with his son-in-law, Alexander Hamilton, to secure New York's ratification of the federal Constitution. He also established the first canal company in the state in 1792 to facilitate navigation from Albany to Oswego. Serving in the U.S. Senate and resolving border disputes with Massachusetts and Pennsylvania also occupied his later years. All in all, the name of Philip Schuyler deserves to be remembered well.

In contrast, the name of another general at Saratoga has become synonymous with treachery: Benedict Arnold is sec-

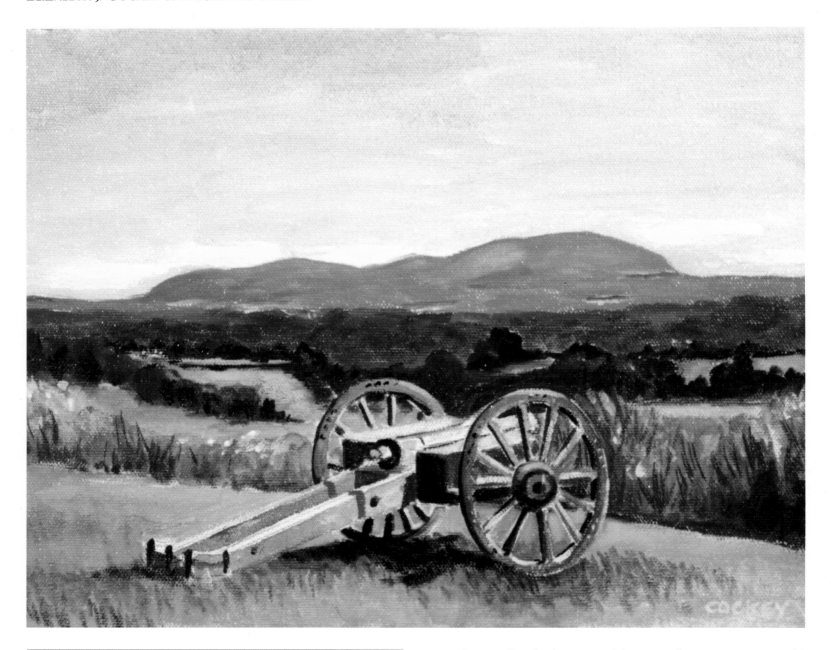

Burgoyne's Redoubt
2007; gouache on canvas;
9 x 12 in.

This view is from the eastern side of the Saratoga Battlefield, and it overlooks the Hudson River Valley into Vermont. Standing here it is easy to understand why General Burgoyne would have chosen this part of the battlefield to position his troops. The battlefield itself covers many more acres at the top of a large hill; it is so vast, in fact, that both the British and the American troops were stationed there simultaneously.

ond only to Judas Iscariot in the lexicon of infamy. Brilliant, brave, and energetic, Arnold had a character deficiency that showed up repeatedly in his war career: his brittle honor was easily slighted. By the time the British forces approached Saratoga, Arnold had already been a leader in numerous fights in the North Country. He had accompanied Ethan Allen to Ticonderoga, demanding to take command of the expedition.

Somehow, Allen had managed him on that occasion. Arnold had led forces to invade Canada in support of Montgomery, and using his Connecticut seafaring skills, he had improvised a small, short-lived navy on Lake Champlain, hindering the British advance.

Initially on good terms with both Gates and Schuyler, Arnold directed the troops at the first Battle of Saratoga on September 19, 1777, apparently taking more initiative than intended by Gates, who remained in the rear. After the action, Gates removed him from command. On October 11, Burgoyne sent fifteen hundred troops to try to find a way around the west side of the American fortifications on Bemis Heights. Although officially removed from authority, Arnold took the field with Morgan's riflemen. Atop a large, black horse, he led three regiments of his former followers in repeated charges. Seeing that the British General Simon Fraser was rallying the

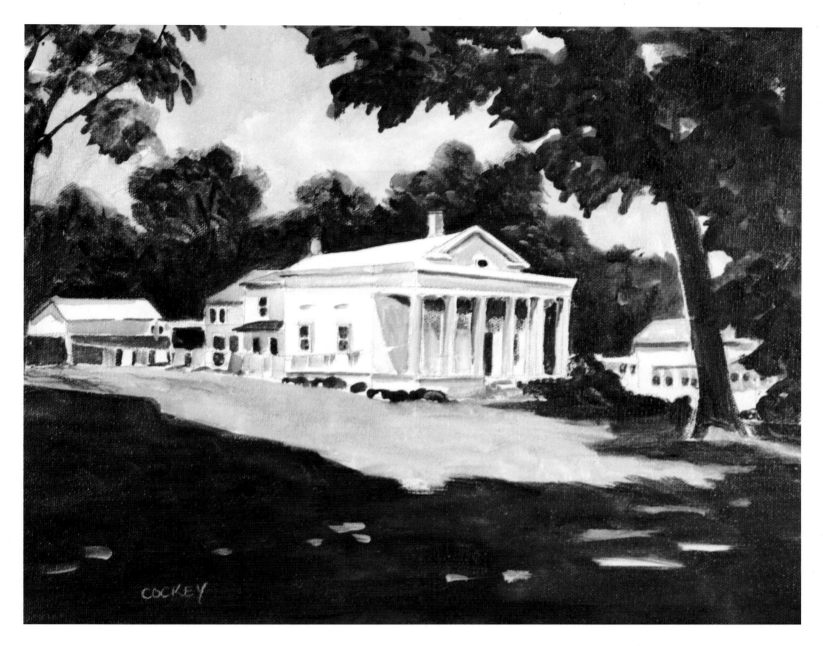

enemy, he gave instructions to Morgan to have Fraser shot. Within minutes, Fraser was down, and Arnold led an assault on Breymann's redoubt, on the west side of the British fortifications. The capture of this stronghold left the whole British line open to attack and forced Burgoyne to pull back. In the charge, Arnold took a ball in the leg, aggravating an earlier wound received at Quebec. Although he was the undoubted hero of the battle, Arnold was snubbed by Gates, who took all the credit. A year later, having married a loyalist while recovering from his wound, Benedict Arnold offered to sell out West Point to the British.

Much has been made of the fact that if Benedict Arnold had been killed at Saratoga, he would have been remembered as one of America's greatest heroes. Touring the battlefield, I suggested that the story could have had an even happier ending if he had married the right woman,

House on Green Street
2007; gouache on canvas;
9 x 12 in.

We were driving around in Schuylerville, looking at the Victorian and Colonial architecture, and this house grabbed our attention. I think it was because of the juxtaposition of a stately home next to a clothesline filled up with wash. In some mysterious way, it was all very homey and cozy, especially the way the sunlight was dappling the lawn out in front. The wash might have seemed out of place to us, but we still felt as if we were looking at a place outside of time.

but Park Ranger Arnold (no relation but a lifelong student of Benedict's history) would have none of this notion. He said that the eighteen-year-old bride did not influence her new husband's treasonous decision. Recently discovered documents in the British archives prove that he was conspiring with the English months before his marriage. I

still think that a patriotic woman would have produced a different outcome.

The American success in this battle persuaded the French government to support the rebellion, paving the way for the final victory at Yorktown. This crucial battle at Saratoga is not to be confused with the battle of Schuylerville, which happened much later.

The battle of Schuylerville was fought in 1968. After the

A Place in Time
2007; watercolor;
16 x 20 in.

Typical of many back porches in upstate New York, this one was filled with all kinds of stuff: chairs with broken legs, old handblown bottles, a quilt that was lying over an armchair, several two-by-fours, cans of paint, and stacks of magazines. The porch was located on the side of the house and was surrounded by numerous beds of flowers, antique statuaries, and herb gardens. For twelve dollars, we purchased an old table that we found on the porch. What a wonderful place!

defeat of the Schuylerville High School football team at the hands of the Greenwich team, a convertible full of cheerleaders from Greenwich arrived in Schuylerville and proceeded to drive up and down the main street. The cheerleaders, stunning in their lettered sweaters and green pleated skirts, taunted the losers in colorful language. The Schuylervillians responded by pelting them with eggs.

This initial skirmish ended with the retreat of the cheerleaders back to Greenwich. The tearful account of their humiliation and the pitiful spectacle of the flower of Greenwich's young womanhood bespattered with egg instantly awoke the chivalrous wrath of the youth of the village. Everyone immediately went to Woodard's chicken farm to collect as many eggs as possible. Kenny Woodard handed them out by the box.

Thus armed, the Greenwichers returned to Schuylerville. As the visiting team advanced up Ferry Street and the home team marched toward them, the girls charged into the fight

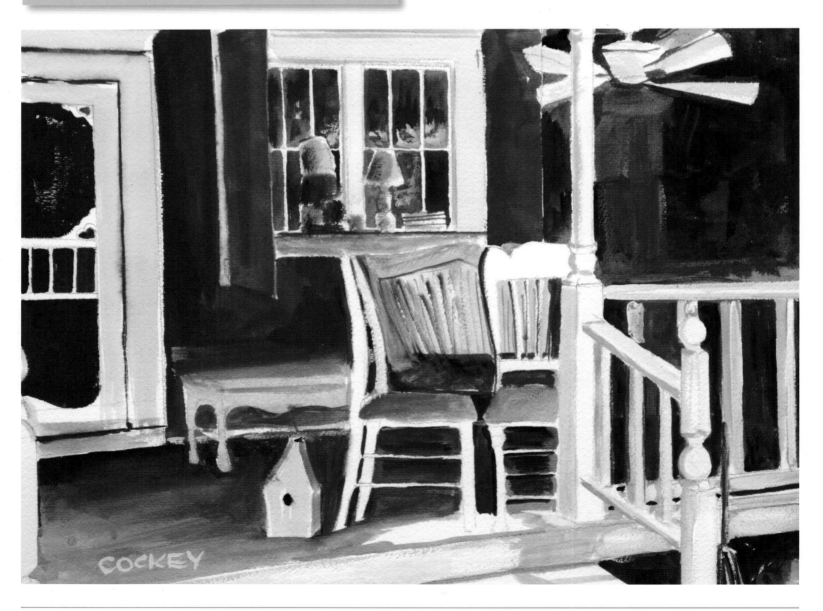

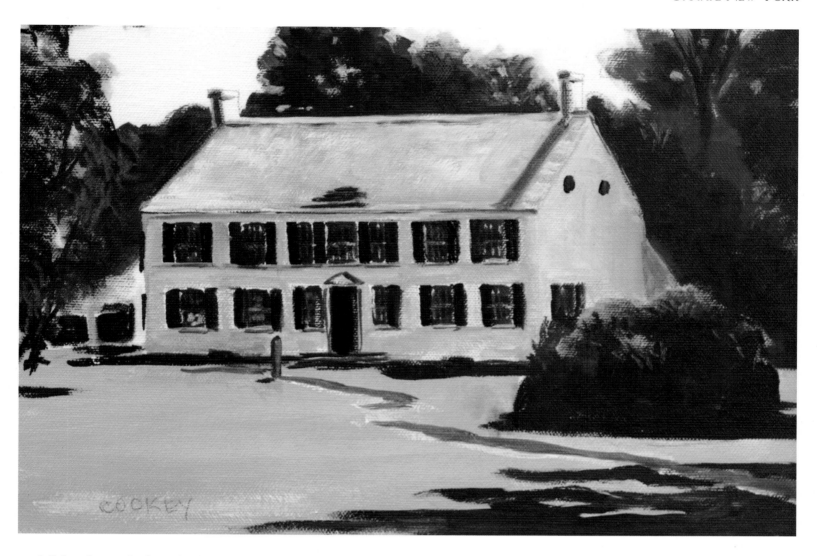

in full battle cry before the boys could even enter the fray. Hand-to-hair combat ensued, with punching and kicking, shoving and scratching. The two sides appeared almost evenly matched. At first, like Gates, the boys held back, startled by the ferocity of the battle. Then, summoning the bolder spirit of Arnold, they unlimbered their egg boxes. As soon as the egging began, it became clear that Greenwich would sweep the field. In this type of engagement, you can't have too many eggs.

Alas, victory soon turned to humiliation when the principal of Schuylerville High phoned his Greenwich counterpart and demanded an apology. The cheerleaders, under threat of a two-week suspension from school, capitulated. Before an assembly of the entire Schuylerville High School, they professed to be sorry and promised not to do it again. Still, everyone knew the apology was not an earnest one, and a forced confession is a hollow thing. The veterans of the battle of Schuylerville hold their heads high to this day. Elizabeth says, "We loved it. It was invigorating."

The Philip Schuyler House
2007; gouache on canvas;
9 x 12 in.

The Schuyler House is located just south of Schuylerville, off Route 4. General Philip Schuyler built this house for his family in the 1700s. Today it has been restored and is now a museum that is open to the public most of the year.

A Monumental View (*Next page*)
2007; gouache on canvas;
16 x 20 in.

There is an old orchard on top of the hill (when heading east on Route 29) before you come into Schuylerville. Here it is possible to see the Schuylerville Monument within the context of the landscape. I loved the fact that it is surrounded by fields of potatoes and by the apple orchard, once owned by Bullard's Orchards, where I picked apples as a young teenager for fifty cents an hour.

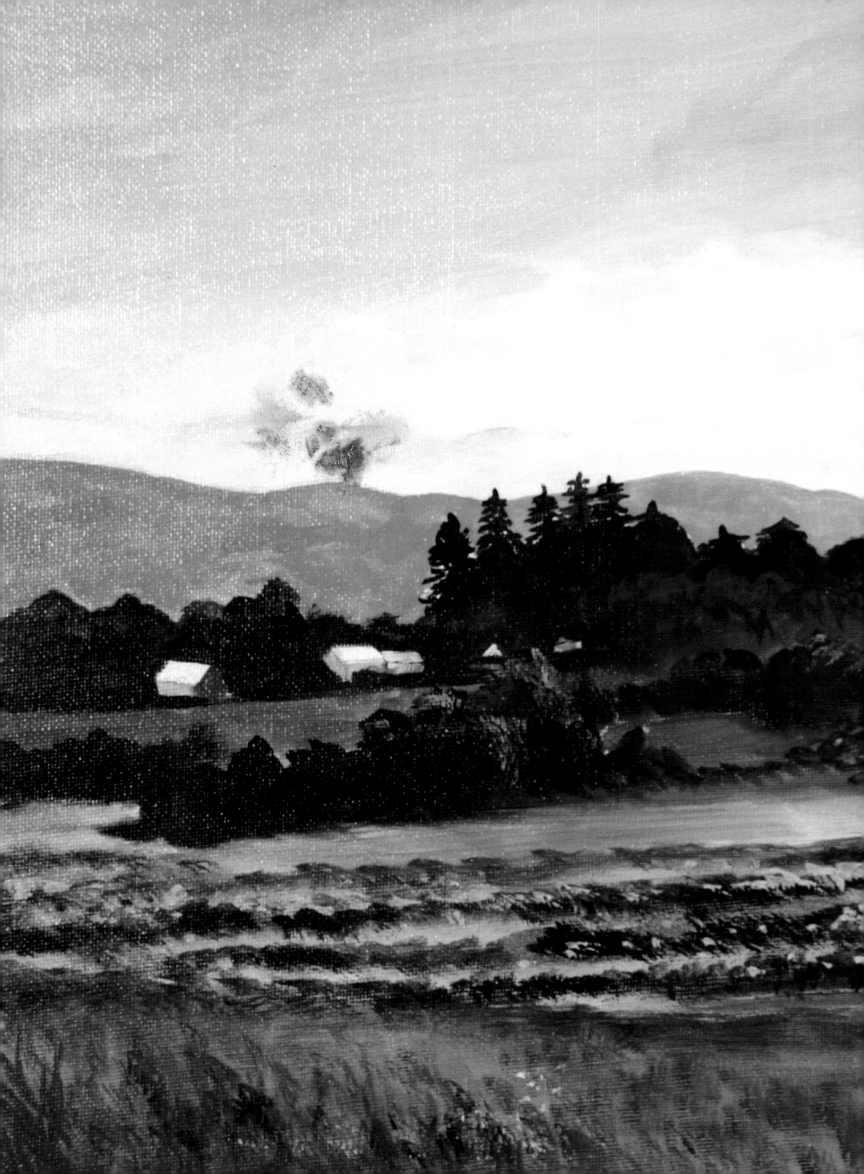

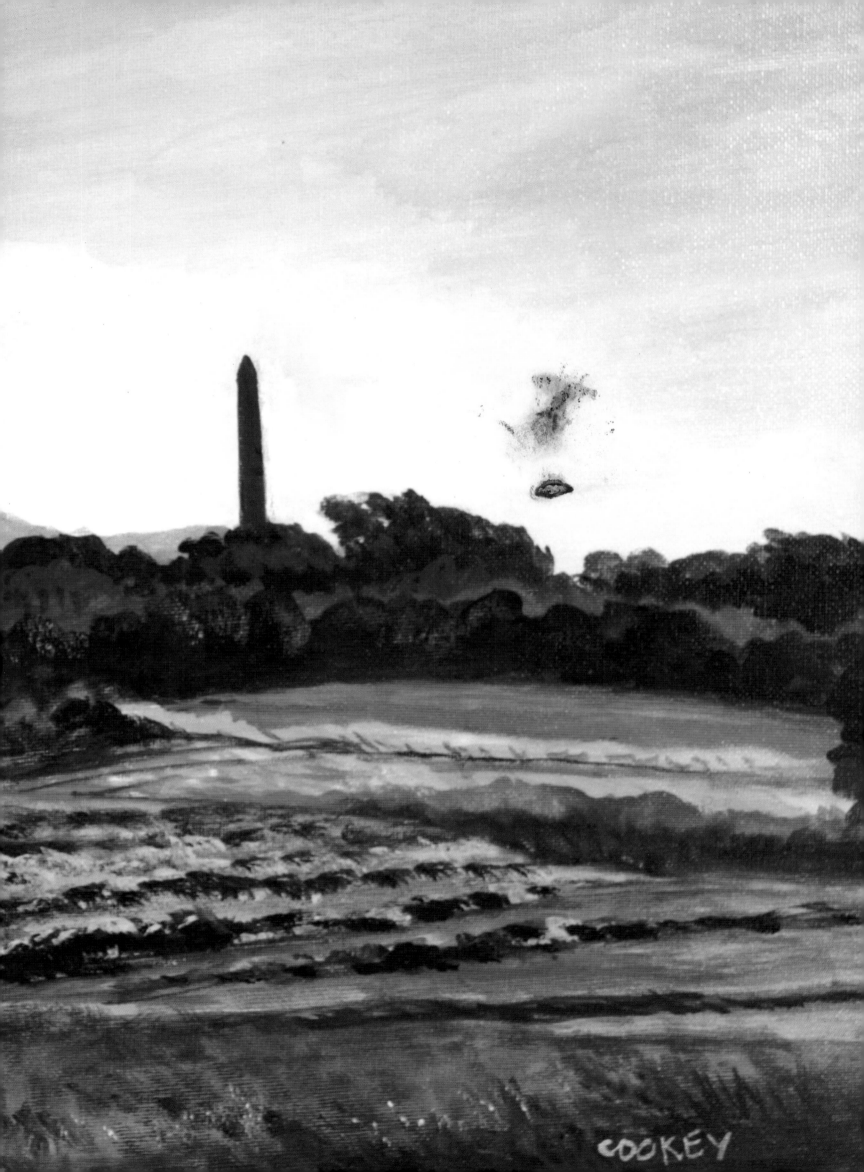

Opportunities for aerobic exercise are still available here, though in a less combative form. The hilly streets offer a good workout combined with a view of the charming Federal and Victorian houses. A climb up the Saratoga battle monument is also good for toning up the old quadriceps femoris. The monument is a sight to see, as it combines the features of an Egyptian obelisk with Gothic peaks and arches; fancy iron-work on the stairs; and large, bronze bas-reliefs of key events such as the murder of Jane McCrea and the wounding of Benedict Arnold. I particularly like the two bronze plaques contrasting the effete, haughty women of the British court to the frugal, industrious women of the American Revolution. No mealy-mouthed relativism here.

The interior of the monument is open only in the summer; so it was a warm day when Elizabeth and I puffed our way to the top. The view was well worth the climb. The last time Elizabeth came up here was when she was in high school, with some friends and a six-pack of beer, just before the state closed the monument in 1970 because of safety concerns. The metal stairs had come loose from the granite walls. Nobody fell, but they all had a good scare. Thirty-two years and over three million dollars later, the monument was reopened, and today it is still in perfect shape.

Old Red Barns
2008; gouache on canvas;
11 x 14 in.

Old, weathered, red barns are a familiar site in the country-side, as are the cows that graze on the hillsides. This scene is typical of many farms that still exist in this part of New York. The barns may be weathered, but they are as resilient and full of life as the folk who farm here.

CHAPTER 3
Saratoga Springs

A fault between the hard Laurentian mountain rocks and the softer Trenton limestone and Hudson River slate creates a crack through which mineral-rich waters bubble to the earth's surface. The Indians had visited the font of these medicinal waters for centuries before the white man came. Here was a winding stream and a clear lake called Caniaderiossera, where the Indians came for the spring herring run, trapping the fish in wicker baskets set in openings in stone dams between the stream and the lake. The woods teemed with game that was said to have sweeter flesh than any other because the animals drank from the springs that the Great Spirit had blessed. A fierce tribe, the most powerful and most feared warriors in the mighty Iroquois League, guarded this rich hunting ground. They had driven out the Algonquin, who called this tribe Mohawk, meaning "man-eaters." The celebrated cruelty of the Mohawk to vanquished foes had considerable public-relations value in discouraging competing claims to their territory, and they adopted the name happily.

The French aroused the enmity of the Mohawk early on with Samuel de Champlain's 1609 expedition into Iroquois lands. A brief skirmish at Ticonderoga taught the Mohawk to respect the power of firearms and metal armor and to distrust the French. This incident allowed Dutch and English influence to predominate in the wilderness that was to become Saratoga.

206 Circular Street
2007; gouache on canvas;
11 x 14 in.

My grandparents, Harold and Edith Smith, lived in this house when I was growing up. Their house was typical of many of the houses in that particular neighborhood: small bungalows or two-family dwellings. Skidmore College was up the street, and around the corner was High Rock Spring where we would fill up jugs with spring water. Every August my grandparents rented out the top floor of their house to the head of Pinkerton Security and his wife while they were in town for the races at the Saratoga Racetrack.

In 1738, a poor, twenty-three-year-old Irishman named William Johnson came to the wilds of New York to look after lands owned by his uncle, Sir Peter Warren, a naval hero. An honest man with the Irish gift of storytelling, Johnson soon made friends with the Indians, learning their language, dressing like them, and participating in their rituals. He married a poor German girl who bore him a son and two daughters and died young. Prospering in trade, he added to his holdings and was soon recognized as one of the most important men on the frontier, both because of his wealth and by virtue of his influence with the natives. Then he met a beautiful Indian girl named Molly Brandt, sister of the Mohawk war chief, Joseph Brandt. His relationship with her appears to have been as passionate and unconventional as the rest of his life. Although married in an Indian ceremony, he never acknowledged her as his wife under English law, referring to her in his will as his "housekeeper." She bore him children and was a brilliant and inventive hostess who entertained his many distinguished guests at his manor house on the edge of the wilderness. Their parties were the talk of two continents, as titled people from across the Atlantic feasted with painted Mohawk warriors who often camped on the lawn.

In 1755, he led warriors from the Mohawk nation against Baron Dieskau's French and Indian forces at Lac du Saint Sacrement. He carried the day, but his old friend and ally, Hendrick, the seventy-year-old Mohawk chief, died in the battle. Johnson himself was hit in the thigh by a musket ball. Knowing that it matters greatly what something is called, he renamed the waterway Lake George in honor of the king.

By August of 1767, at the age of fifty-three, Sir William Johnson was worn out. In constant pain from gout and with a throbbing ache where a large-caliber lead ball still lay buried in his thigh, he could scarcely walk. His Indian friends then gave him a gift more precious in their minds than all the lands they had given him and the lives of all the warriors who had perished at Lake George; they carried him to the healing spring deep within their hunting ground. He and the red men camped beside a strange cone of light brown travertine, from whose depths there issued forth effervescent water laden with the minerals that had slowly built what has come to be called the High Rock Spring. Reinvigorated by the waters, Johnson was able to walk back along the rough trail. Although he was

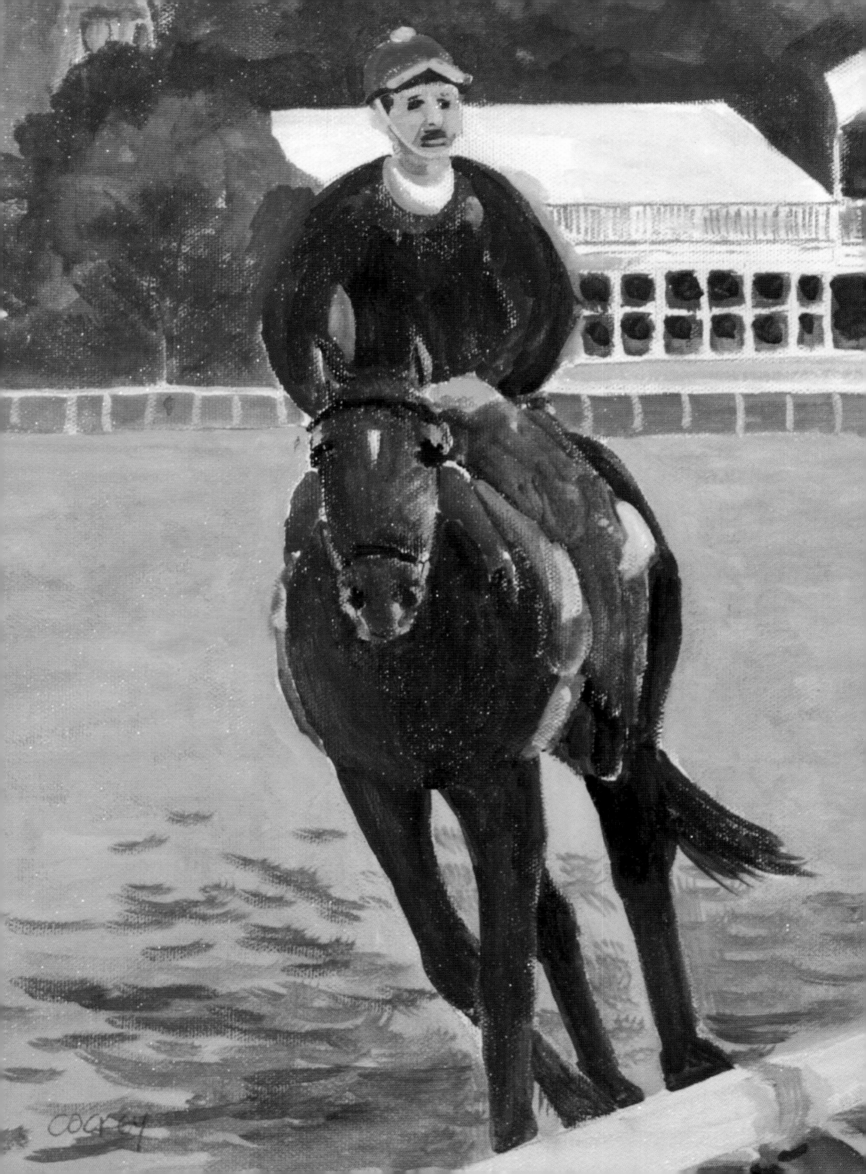

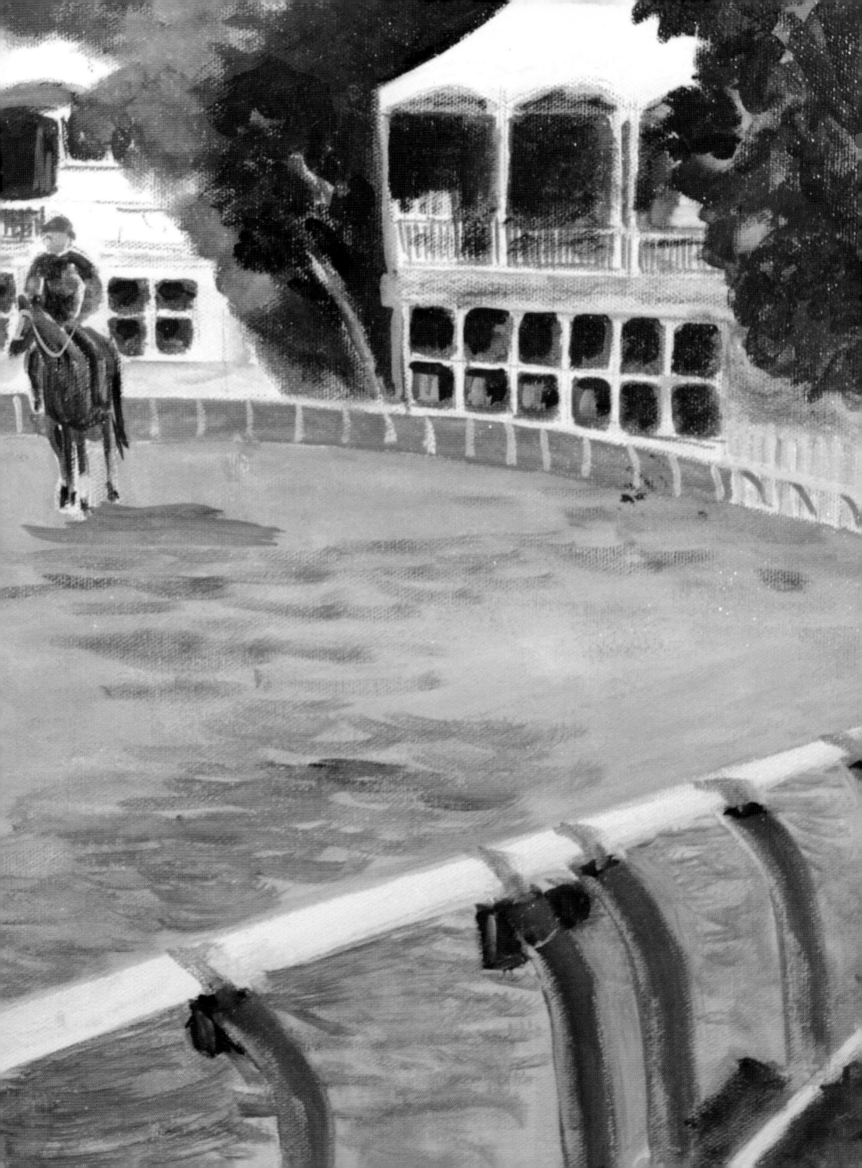

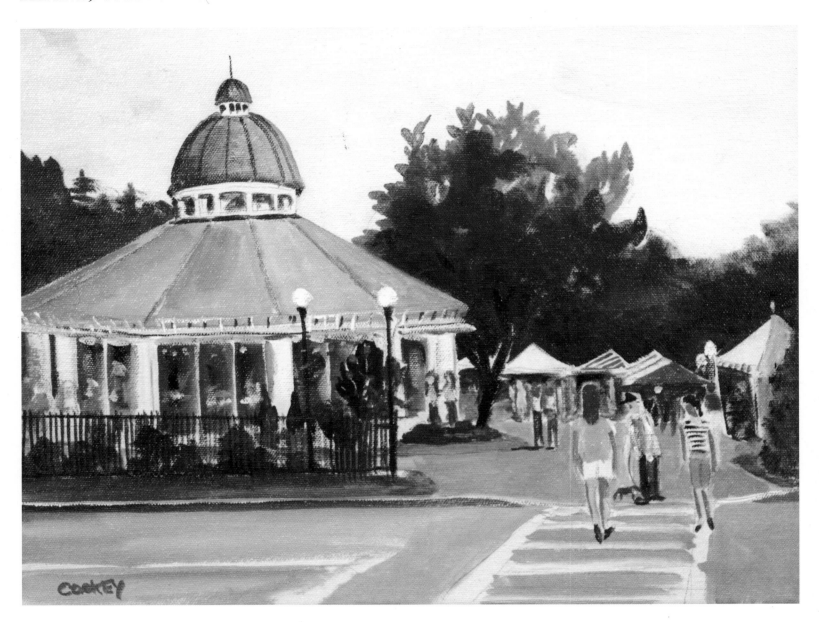

probably not the first white man to see the spring, he was the first to report on the curative properties of its water. His renown as a hero of the frontier made the account of his cure all the more newsworthy.

Death in 1774 spared Sir William Johnson from the turmoil of the War for Independence. He would surely have taken the British side as his son and his Mohawk brother-in-

Morning Workout at the Track (*Previous page*)
2007; gouache on canvas;
16 x 20 in.

The Saratoga Racetrack is the oldest racetrack in the United States; it is a historic and majestic place for family entertainment and exciting races with famous jockeys and valuable horses. Every August the track opens its gates to the general public, and people come from all over for an entire month of gaming and enjoying the end of summer. In the early morning hours, it is possible to go out to the track, have a cup of coffee, and watch the Thoroughbreds as they lope around the track for exercise.

The Carousel
2007; gouache on canvas;
11 x 14 in.

Located in historic Congress Park in downtown Saratoga, the old Carousel was restored and then kept in good repair by putting another building around it. It is a great place to take the kids for a ride, visit the numerous mineral springs that run perpetually out of the ground, and browse local arts and crafts fairs that are part of the summer programming. You can also listen to a variety of free concerts at night throughout the summer.

law did. It was not until 1783 that Philip Schuyler, a hero of the new nation, cut a road from his property at the mouth of Fish Creek to the High Rock spring. This rude trail, which swung wide to avoid the swamps, was well north of the more direct, modern Route 29. Schuyler had learned of the spring from Johnson and built a rough cabin there in 1784, where he and his family and guests stayed every summer amid bears,

COCKEY

wolves, catamounts, and rattlesnakes. George Washington visited the spot as Schuyler's guest in 1783 when the only accommodation was a tent. He liked the place so well that he tried, unsuccessfully, to buy land there.

Gradually, a small town grew up as lodgings were built and tourists came to take the waters. Gideon Putnam put up his tavern and boarding house in 1803. The reptiles and larger carnivores thinned out as more people moved in and additional springs were discovered and developed.

The rise of Saratoga as a tourist destination might have been more rapid but for two factors. The first was an abundance of competing resorts. With the discovery of other springs offering oil, salt, sulfur, and nitrates, not only in New York but all over the East from Virginia to New England, the spring that restored Sir William became merely one among many. And there was always the sea, with all the saltwater and fresh air anyone could desire.

Union Avenue
2007; gouache on canvas;
9 x 12 in.

There are many stately Victorian mansions that line Union Avenue in Saratoga Springs. When the racetrack opens in August, these same mansions are rented out for the racing season. In fact, many individuals also rent out their private homes for the entire month, which is a great way to make several thousand dollars every year. Skidmore College's campus was located up and down Union Avenue and Circular Street before moving to another location in the early 1970s.

The second damper was the arrival of the evangelist Dr. Billy J. Clark, who decided that this healthy place was just the spot to showcase the virtues of the abstemious life. He founded the nation's first temperance society here, and visitors enjoyed the absence of such tools of Satan as alcoholic beverages, card playing, and dancing. No one was allowed to arrive or leave on Sunday, which was given over to prayer, hymns, and quiet.

Guests had such a religious experience that in no time at all, they found themselves longing for the hereafter. Ballston being closer than the Blissful Shore, they made their way thither.

A decade of sobriety took its toll on the fortunes of the hostlers of Saratoga, and in 1819 the village of Saratoga Springs contrived to become a "special township" and was able to make its own rules, regardless of the disapproval of all the moralists in the neighborhood. Promotion and sale of bottled water from Congress Spring by Dr. John Clarke spread the fame of Saratoga water and more than compensated for the other Dr. Clark's influence. By 1830, Dr. Clarke was shipping twelve hundred bottles a day to buyers all over the world. In 1833, steam locomotives began bringing vacationers to the increasingly elegant hotels for gambling, stage shows, and dancing. After another decade, the town would be hopping with that low, indecent, foreign dance—the polka! Horse racing and casino gambling followed, and the glitterati of the nineteenth century flowed through the town in an unending parade.

An early morning visit to the track was just right for me; I don't care for crowds. Our friend Bob Wright gave me a tour of the clubhouse and racetrack grounds. Trainers and helpers were exercising the horses on the 1⅛-mile dirt track, faster traffic going counterclockwise on the inside and slower movers clockwise on the outside. Only one was galloping at full speed. Most were walking, occasionally pirouetting impatiently as if to ask, "Why am I here if not to run?" A sleek chestnut stallion ran by, snorting heavily, his head down, the reins taught; the rider was holding him back. A sturdy gray had just made his third lap and seemed to be enjoying himself.

Congress Park
2007; gouache on canvas;
16 x 20 in.

The casino was where gambling took place in prohibition days. Today, it is a museum featuring many delightful artifacts from days gone by, and it is a prominent building within historic Congress Park. Out front there is a large pond where anyone can eat a picnic lunch and enjoy feeding the ducks and watching the people go by. Many love to sightsee or go for a walk in the park.

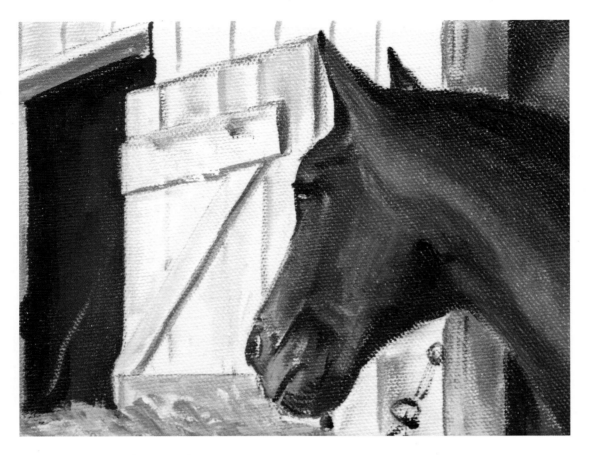

Horse Barn
2007; gouache on canvas;
5 x 7 in.

While I was photographing this beautiful animal, an armed guard walked up and wanted to know what I was doing there. This Thoroughbred might have been just munching hay, but she is a valuable investment for her owner, who has to pay top dollar to board her at the track. All I wanted to do was reach out and pet her. No wonder they have to hire guards!

named after the president of the old Saratoga Racing Association. During my visit, the canoe was painted red in honor of the 2006 winner, Bernardini, from Darley Stable, which is an enterprise of HH Sheikh Mohammed bin Rashid Al Maktoum, the ruler of Dubai. Saratoga has long had an international flavor, and as they say, it's a small world.

We peered into the building that houses the brightly colored racing silks. Before each race, the jockeys go into the silk room to pick up the colors they are to wear. Imagine! In this disposable age, at a track where each buyer of a three-dollar admission ticket receives a "free" folding chair, they actually reuse the shirts for the jockeys. Ah, tradition. I love it.

A drive through this town is a pleasure, even in the bustle of racing season. Elegant and opulent, the houses and hotels recall the resort's glittering past and reflect its current prosperity. The ornate nineteenth-century architecture is a pleasure to the eye. Once in a while, we like to take a walk under the lush shade trees, past the manicured gardens to the house on Circular Street where Elizabeth's maternal grandmother lived. It was a treat for a little farm girl to spend her weekends in the big house and ride in her grandmother's Cadillac; Grandmother's propensity for running into things with the car added to the excitement. When we visited, Elizabeth was happy to see that the brick sidewalk was still in place in front of the house and that the years had spared the old carriage house where she used to play.

The inside of the clubhouse looks like private enterprise at its most efficient, and I marveled at all the betting windows. Bob confided that he occasionally places a two-dollar bet, which is heavy gambling by my standards. Not for us the ways of the high roller.

Still, even for the non-gambler, there is a lot to like about this track. The buildings have an old-time feel about them. Take away all the TV screens, and it could be the Gay Nineties. Two inner tracks of lush green turf separate the dirt track from the infield. This infield is a sort of equestrian landscape garden, with a pond in the center. On the pond is a canoe traditionally painted in the colors of the stable of the Travers Stakes winner for that year. The Travers Stakes is the oldest Thoroughbred race in America, first held in 1864 and

From Circular Street, it is a short walk to the spring where Elizabeth and her brother and sister used to fill jugs of water for her grandmother, who, like many residents of the town,

consumed hearty doses of the mineral water every day. The spring water used to run out of an old, rusty pipe on the other side of High Rock Avenue back then. Now the water from the spring of Elizabeth's childhood memories (the "Peerless Spring") is piped under the street to a fountain under a lovely Victorian-style pavilion. The High Rock Spring, too, is covered by an elegant pagoda. Stairs lead down into a little hollow containing a dry, iron-stained rock about a foot and a half high. In old photographs, a dipper boy in a dark suit stands ready to ladle out a dose of mineral water. In the summer of 2007, however, the dipper boy was nowhere to be found, and no water was flowing from the central hole in the rock, though a sign on a nearby marker explained that water is piped to the High Rock from another spring. Apparently the pipe was not in service that day.

That the rock is still there at all is enough for me. The little park around it has a serenity that defies all the traffic. Even with the bustle of a farmers' market a hundred yards away, the mind's eye can still conjure the image of Sir William Johnson and his Indian friends resting by their campfire. Elizabeth was astonished to discover that this historic spring was just a block

Yadoo Gardens
2007; gouache on canvas;
9 x 12 in.

Built in the 1800s and then rebuilt after it burned to the ground, the gardens are a place of respite and quiet. The water feature here shows a beautiful statue that leads up to the main house. Now a private residence for prominent artists and writers to come and work their craft, Yadoo is a historical delight, with rose gardens and topiary sculptures that are all truly works of art.

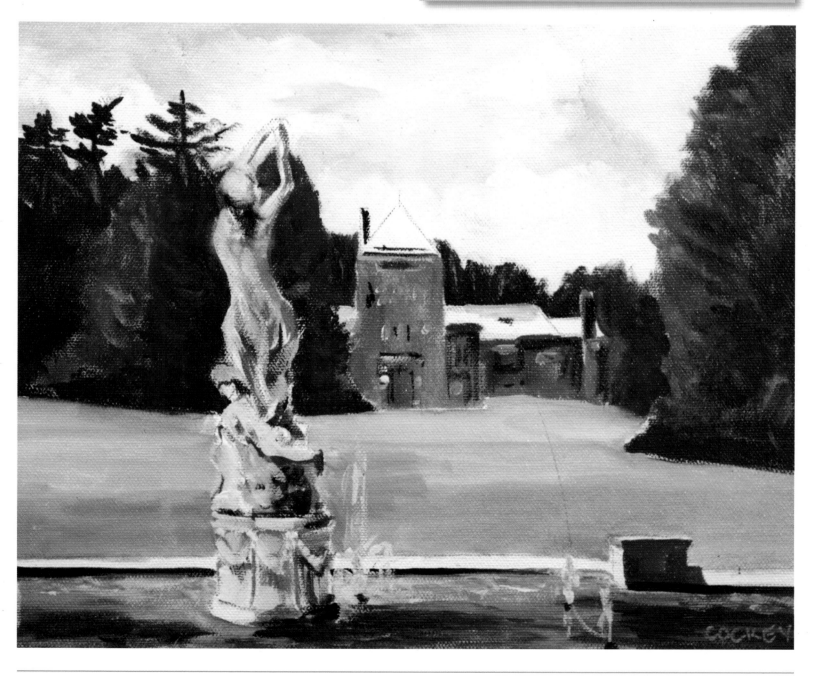

away from her grandmother's house but that she didn't know about it at the time.

Sampling the water from the different springs is like a wine-tasting tour without the risk of intoxication. If the water from your well tasted like this, you'd be scarcely willing to bathe in it; but viewed as a natural medicinal brew, the product of Saratoga's various springs is delicious. My personal favorite is the Peerless, but Hathorn number one is a close second. Both have a satisfying complexity, with plenty of iron and sulfur as well as salt and a hint of effervescence. Some recommend Hathorn number three as a more robust mineral flavor, with the added benefit of cleansing the bowels. Milder water, slightly saline, comes from Congress Spring in the park of the same name and is the stuff that Dr. Clarke bottled. Even the city water issuing from the fountain on the site of the now-dry Columbian Spring will taste salty to the nonnative drinker.

Part of the flavor of Saratoga comes from its status as a college town with pretty coeds sunning on the lawn in Congress Park and intellectual-looking chaps with eyeglasses chatting in the coffee houses. Skidmore College has over twenty-four hundred students in a town of slightly over twenty-six thousand. Add in faculty, employees, and the odd hanger-on, and you have an academic presence equal to a tenth of the population. The college started out in 1903 as the Young Women's Industrial Club and was founded by Lucy Skidmore Scribner with money inherited from her father, who was a very successful coal merchant. In 1911, the club became the Skidmore School of Arts, devoted to women's professional and vocational training. Gaining in stature over the years, it received an independent charter as a four-year college in 1922.

By 1961, Skidmore had outgrown its eclectic agglomeration of interesting, old, downtown buildings and moved to the current 850-acre campus. The trees have grown up nicely since then, softening the starkness of the red brick and glass of the 1960s and 1970s architecture. Like many women's colleges, Skidmore went co-ed in 1971, but it still seems to have been able to retain something of the woman's perspective. A recent article in *Sierra Magazine* features an interview with Mary Zeiss Stange, an associate professor of religion and women's studies at Skidmore. An avid hunter and author of *Woman the Hunter*, Professor Stange points to the nexus between hunting and environmentalism. She explains that we simply do not have the option of being mere photo-snapping tourists dropping in on nature for a visit. We perturb the lives of other sentient creatures whether we intend to or not, even if we eat nothing but vegetables. Hunting, says Stange, disallows the unrealistic notion that we can be passive observers of the ecosystem. Conscious, active participation as an intelligent predator demands responsible engagement with nature. She notes that the hunter-goddess Artemis was also the goddess of birth, for hunting involves a healthier and more realistic participation in the life-death-birth cycle than one can achieve at the supermarket. I have no idea whether all of Skidmore's faculty are as interesting as Professor Stange, but the students look happy.

Spit and Spat
2008; gouache on canvas;
9 x 12 in.
One especially pretty section of Congress Park in Saratoga is the Italian Garden with fountains called "Spit" and "Spat." The two spew water across the pond at one another from shell-like horns, and the overall effect is delightful!

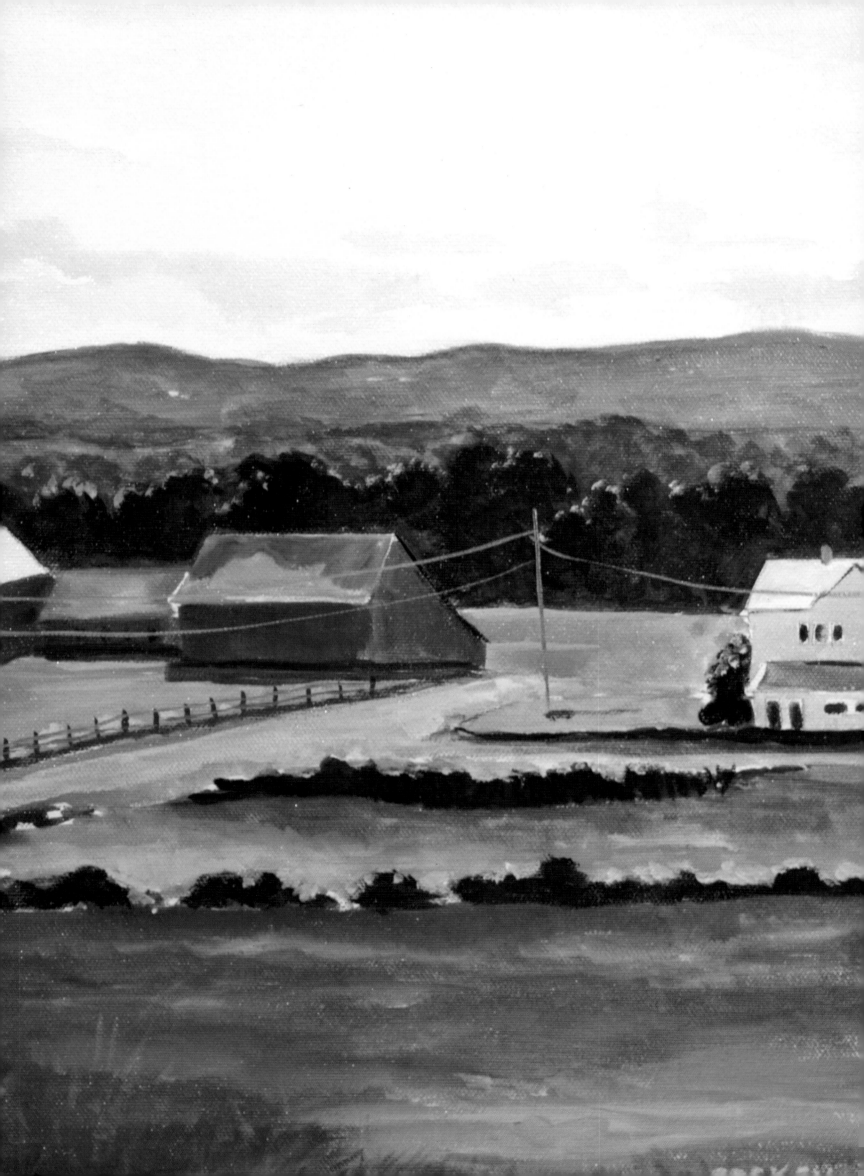

CHAPTER 4

Easton

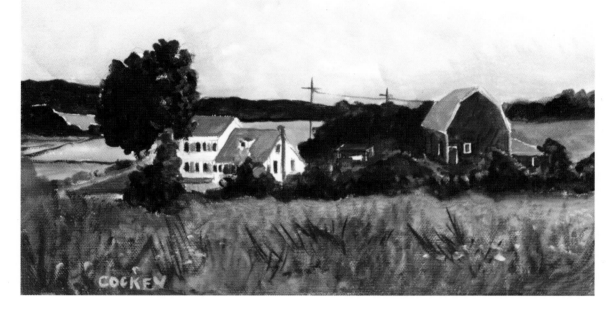

The Town of Easton is still mostly farm country. The flats along the Hudson, still prone to flooding despite the dams and locks, are rich, fertile loam, with hardly a stone in them. The adjacent hills are full of stones, but the sturdy farmers are accustomed to the hard work of pulling rocks out of fields. The picturesque stone walls represent centuries of such labor. In days past, draft animals or a tractor would pull a wooden raft called a "stone boat" over the field, and the rocks were pried up and rolled or heaved onto it, to be dragged to the nearest wall.

Many of the farms are still owned by the descendants of the first settlers. Job Wright purchased his farm along the Hudson shortly after the French and Indian War. His descendants have worked it ever since, although more recently the fields have been cultivated by another local farmer with a large-scale operation and modern equipment. From the Wright farm, you can look across the Hudson to the Great Redoubt of the British forces at Saratoga, where deer are browsing among the cannon on the battlefield. The place has a timeless feel. But for the paved road and utility poles, this could be 1907 or even 1807.

Yet there are changes below the surface. Tenants rent the farm house, and the Wrights of my generation are all engaged

Easton Farm
2007; gouache on canvas;
11 x 14 in.
I have always admired this farm off Route 40 on the way to Easton. There is a farm pond out in front of the barns that I didn't paint but that has a fountain right in the middle that spurts water all the time!

The Wright Farm
2006; gouache on canvas;
11 x 14 in.
The Wright family has owned and operated this farm for over two hundred years. The farmhouse faces southwest and sits near River Road, which winds along the Hudson to Albany. On the opposite side of the river, one can see a portion of the Saratoga Battlefield and Burgoyne's redoubt.

in nonagricultural occupations. They return to enjoy the old homeplace and to do maintenance work. Farming is an industry, albeit more pleasing to the eye than a steel mill or a factory. The work can be dirty, smelly, and dangerous, and the financial rewards for the small farmer have become more and more meager. No wonder there are fewer sons and daughters of farmers staying on the land. Yet there is a wonderful freedom in growing up in the country, swimming and fishing in the river, playing in the barn, and hunting in the woods and fields. As the Wrights agonize over the future disposition of the property, I feel a pang of melancholy at the thought that the next generations of this family and so many others will miss out on these experiences. So it was with my own family two generations ago. Upstate New Yorkers have managed to hold out longer.

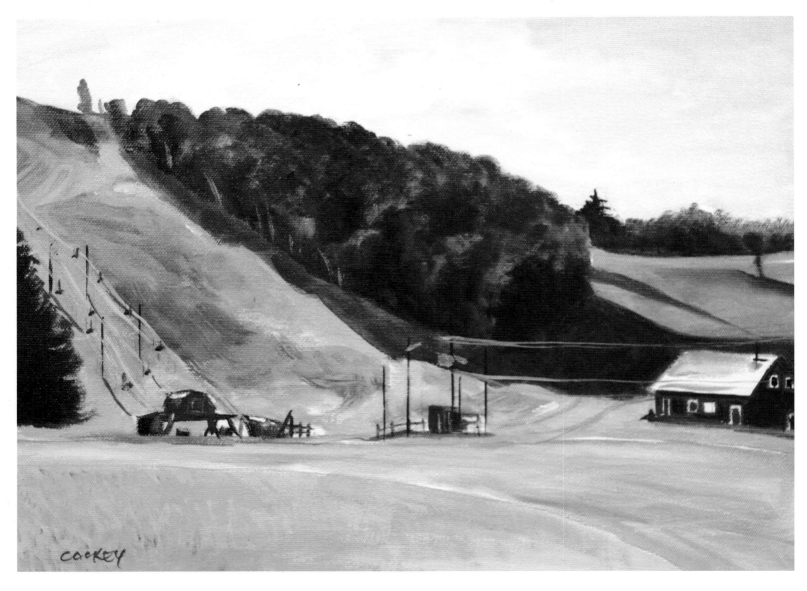

Willard Mountain
2007; gouache on canvas;
11 x 14 in.

The ski area is always a pleasant spot to visit any time of year. During my high school years, I skied nearly every weekend in the winter months and on some nights as well. Willard Mountain became a great winter activity for most people in the area, drawing a crowd from as far away as Saratoga, Troy, and Albany. It is still operating today, and more trails and lifts have been added to take skiers to the top. The view from there is absolutely magnificent.

Driving along the rural roads with Elizabeth and her friends is always an education in local lore, as each turn reveals a new wonder. No, they are not growing truck tires on those big mounds covered with black plastic. It's a new and less picturesque way of storing silage. Those things that look like white, plastic doghouses all in a row are shelters for calves in a big cattle-raising facility. The young calves are less prone to respiratory diseases if they live in the fresh air rather than inside a barn.

"Look! All the cows are lying down! That means it's going to rain!" This prediction appeared fairly safe; after all, it seems to rain every time we come to Greenwich. But wait, there is a caveat: the whole herd has to be lying down for the forecast to be reliable. Apparently, if only two or three are lying down, we're looking at partly cloudy.

Here and there, the traveler encounters a farm with a particularly impressive line of rusting tractors along the road. The house could do with some paint. This, according to our Greenwich friends, is the abode of woodchucks.

In these parts, a woodchuck is not just a large rodent. The term also applies to what in the South used to be called "white trash" but would nowadays be summed up by the term "redneck." An operational definition of a woodchuck would be

anyone whose property is less tidy than yours or has a less-tasteful collection of lawn ornaments and junk cars. Folks in Washington County, New York, say you can tell when you're in Vermont when there are more kitchen appliances on the lawn than there are in the house. Folks in Vermont take the opposite view.

According to a plausible local tradition, the original wood-chucks were German soldiers who came here with Burgoyne and settled in these hills and valleys after the Revolutionary War. Before their hard work and determination raised them out of poverty, they lived in crude cabins with dirt floors. Their neighbors apparently took a look at them, shook their heads, and said, "It's none of my business, but those people live like woodchucks." The expression has been in continuous use ever since.

A more reliable source, Tim Tefft, states categorically that woodchuck is a term of more recent coinage but notes that Louse Hill in the Village of Greenwich and the Town of Easton "was so named because 'Hessians' [the locals referred to all Germans as Hessians whether they were from Hesse or

not] who took up residence there lived as you have described and were lousy with lice."

The tranquil farm country of Easton offers no hint of the perils faced by its settlers. Yet the farmers who lived in this valley along the Hudson faced a deadly onslaught in the summer of 1777. British Lieutenant General John Burgoyne of the

White Feather Lodge
2007; gouache on canvas;
11 x 14 in.

As the story goes, an Indian war party came to attack a Quaker meeting in 1777. Rather than take any action, the Quakers simply sat in silence as the Indians entered the building. Before the war party left that day, the chief placed a white feather over the door of the meeting house as a sign that Quakers would not be harmed in future Indian raids. The original meeting house was eventually torn down and replaced, but I attempted to paint the building from the same vantage point that the Indians must have had when they first came upon it.

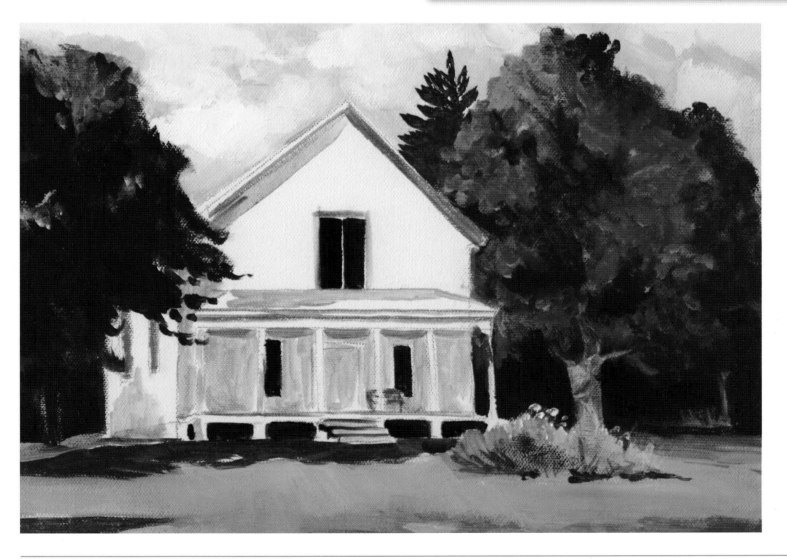

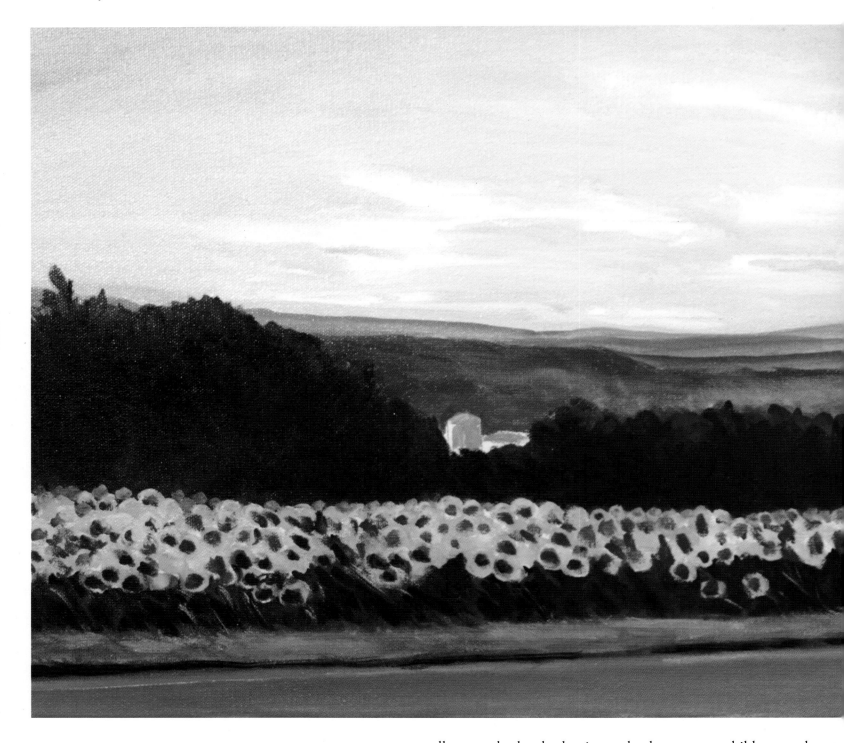

August Sunflowers
2007; gouache on canvas;
9 x 24 in.

The field of sunflowers took my breath away as we drove along Route 40 on the way to the home of our cousin Jon. The bright yellow flowers were a striking contrast to the rolling, dark blue hills behind them.

Queen's Regiment of Light Dragoons was marching his army down from Canada in a maneuver intended to cut off New England from the southern colonies in order to put down the rebellion. He had enlisted in his service the wild Indians of the frontier. These warriors had pledged to him that they would all go to the battle, leaving only the women, children, and old people to tend their villages. They were soon joined by even more hostile red men recruited from the western wilds by the treacherous Frenchmen Chevalier St. Luc de la Corne and Charles de Langlade. These were the same French and Indians who had raided the frontier and murdered English settlers and ambushed English troops in the previous war, and they were all too happy to settle old accounts.

Despite Burgoyne's pledge that loyalists would be under the protection of the British Crown, the Indians who swept down the Hudson Valley ahead of the British and German regulars had other ideas. The Allen family felt safe enough in their homestead near South Argyle, some fifteen miles north

EOCKEY

Two days later, July 27, 1777, Jane McCrea and her friend Mrs. McNeil were sitting on the porch of Mrs. McNeil's house near Fort Edward. Jane was a beautiful young woman. Wearing a wedding dress, she was waiting to be escorted to her fiancé, Lieutenant David Jones, in the nearby British camp. Not daring to approach too close to the rebel forces at Fort Edward, Jones had arranged for a party of Indians to escort Jane stealthily to the British lines. Accounts of the incident vary, but the plan miscarried, and hostile Indians carried off Jane McCrea and Mrs. McNeil. They hustled Jane along on a horse, anxious to distance themselves from the fort, all the while dragging the fat, elderly Mrs. McNeil with them. A quarrel ensued between two of the Indians, and one of them shot Jane and took her scalp. Mrs. McNeil lived to tell the tale.

Word of these atrocities against the king's loyal subjects spread rapidly, hardening the resolve of the rebels and changing the minds of many who might otherwise have stood by or sided with the British. The public outrage against the Indian terror may well have been a decisive factor in the defeat of Burgoyne's army at Saratoga.

Farther down the valley, in the Town of Easton, across the Hudson from the site of the decisive battle to come, a congregation of Quakers sat at meeting. While all around them people were fleeing for their lives, they trusted in providence and waited for the Spirit to move them. Suddenly, a band of Indians, almost naked except for their war paint, feathers, and weapons, burst into the meeting house. The Quakers continued to sit impassively as the braves made faces at them and shook their tomahawks and muskets. After a while, the Indians sat down too. One of the Quakers is said to have risen to recite the ninety-first psalm, nicely picking up the feather and arrow motif:

He shall cover thee with his feathers, and under his wings shalt thou trust: his truth shall be thy shield and buckler.

Thou shalt not be afraid for the terror by night; nor for the arrow that flieth by day…[2]

of here. John Allen was a loyalist, and when a small party of Indians came to his house and asked to stay the night, he fed and lodged them with no fear of harm. A larger group of Indians arrived soon after, but these he turned away, as he could take no more lodgers. No one knows whether the second Indian band came back for revenge or whether other Indians, fired upon by rebels near Salem, attacked the Allens. There is no doubt that a group of Indians, reputedly led by Le Loup, which means "the wolf," crept up to the house and killed Allen, his wife Eva, her three young children, her sixteen-year-old sister, and two black slaves who belonged to Allen's father-in-law Yerry Killmore. The bodies were found scalped and mutilated.

This legend has been told so many times that there are as many variations as tellers. Some say the Indians were impressed by the courage of the congregation; others have suggested that the savages respected insanity as much as bravery and were trying to figure out which of the two phenomena they were observing. Still others believe that the chief sensed the Great Spirit was strong in these people and in this place. A last and least plausible idea is that the warriors did not kill the Quakers because there were no weapons among the worshipers. As the tale of the Allen family massacre suggests, Le Loup and his followers had no such inhibitions. My own guess is that this particular band of Indians was more disciplined than some of the others and was following Burgoyne's instructions, as he put it in his proclamation, not to harm "the domestick, the industrious, the infirm, or even the timid inhabitants."

At length, one of the Quakers stood up and invited the Indians to a simple meal. After they had eaten, the chief drew a white feather from his headdress and stuck it above the door of the building, saying that by this token, the place would be safe from Indian attack. It has been called the White Feather Lodge ever since and, to the best of my knowledge, has not been attacked by Indians.

When peace returned to the region at the end of the Revolutionary War, farming and manufacturing grew. A local boy named George H. Corliss, son of the controversial Dr. Corliss, was born in Easton on June 2, 1817, and found a job as a clerk in William Mowry's factory store. His inventive powers became evident after he opened his own store in 1838 selling leather goods and recognized the need for improved manufacturing techniques. He designed and built gadgets to help him in his trade and devised a machine for sewing harness leather. Moving to Providence in 1844, he joined Fairbanks, Bancroft & Company in the machine business and soon thereafter invented the steam engine that made him famous. Central to the success of this inven-

tion was a patented valve gear that permitted a rotary valve to cut off the flow of steam into the cylinder partway through the power stroke, allowing the expansive force of the steam itself to drive the piston the rest of the way. The fuel economy achieved by this invention was so great that Corliss made a fortune by selling the engines cheap and letting his customers pay him what they saved in fuel costs. Meanwhile, the U.S. government was spending the taxpayers' money on experiments to show that the expansive use of steam would not improve fuel economy. I suppose some things never change.

In addition to fuel efficiency, the Corliss valve allowed the speed of an engine to be controlled very precisely, a valuable feature in textile mills where variation in speed can break delicate thread. Corliss was one of those remarkable American innovators who created the machine age from scratch. He designed and built not only the engines but also most of the equipment required for their manufacture.

Victorian House
2004; watercolor;
16 x 20 in.

The house of our cousin Jon Stevens sits atop Beadle Hill in Easton and faces east toward Vermont. From the front lawn, there is almost a panoramic view of the countryside. The Victorian-style house has many features: stained-glass windows, old pine floorboards, and a library stacked to the ceiling with books on literature, archaeology, and history.

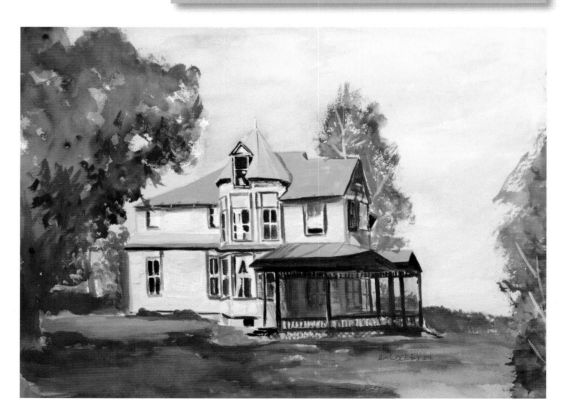

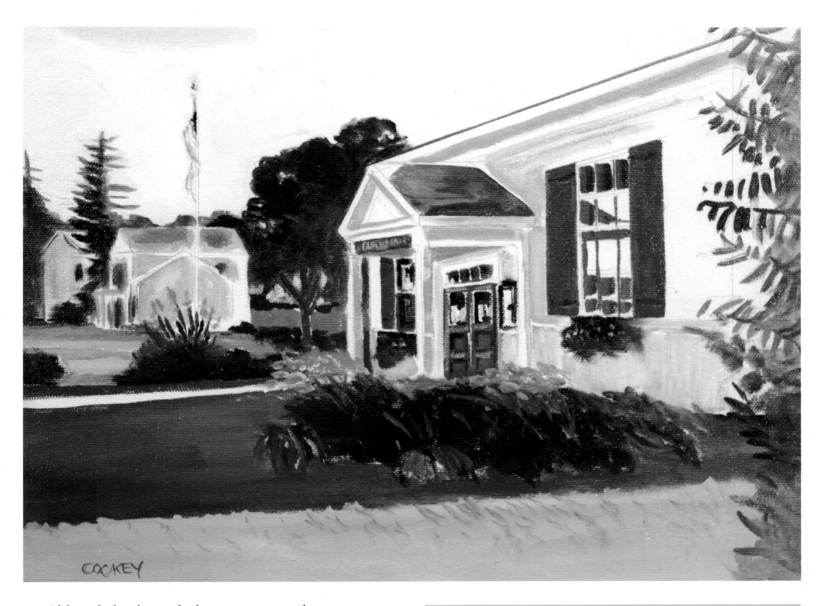

COCKEY

Although hard-nosed about protecting his seventy-two patents from infringement, he had a kind heart. Once, he discovered that a robin had built a nest in one of the wheels of the only vehicle large enough to deliver a boiler. Shrugging off the financial loss, he made his customers wait until the baby robins left the nest.

The biggest Corliss engine ever made was the centerpiece of the machinery at the Centennial Exposition in Philadelphia in 1876. Weighing 650 tons and towering 40 feet above its platform, it powered all the equipment in the Machinery Hall. After the exposition, it served for thirty years providing power for George Pullman's train-car factory. Then it was sold for scrap at eight dollars a ton. A few Corliss engines still survive, notably at the Henry Ford Museum in Dearborn, Michigan. George Corliss's birthplace still stands—a modest, plain white frame house next to the Easton Town Hall on Route 40.

Burton Hall
2007; gouache on canvas;
11 x 14 in.

Burton Hall is the main meeting place in Easton. All year long, in addition to other local events, there are numerous plays that are produced and performed by local musicians and thespians. The inside of the hall feels like a church with old pine floorboards and with folding chairs in lieu of pews. The stage, which rises up in the front of the room, was once surrounded on each side by old velvet curtains, with a mural of local scenery in the background. The overall effect was quite charming.

View of Vermont (*Next page*)
2007; watercolor;
24 x 30 in.

Grandma Moses lived in these parts and probably even painted a scene similar to this one. The countryside rolls down and then up, forming round hills that seem to go on forever into the distance. And in that distance, you can just barely see the tops of church spires in Bennington, Vermont.

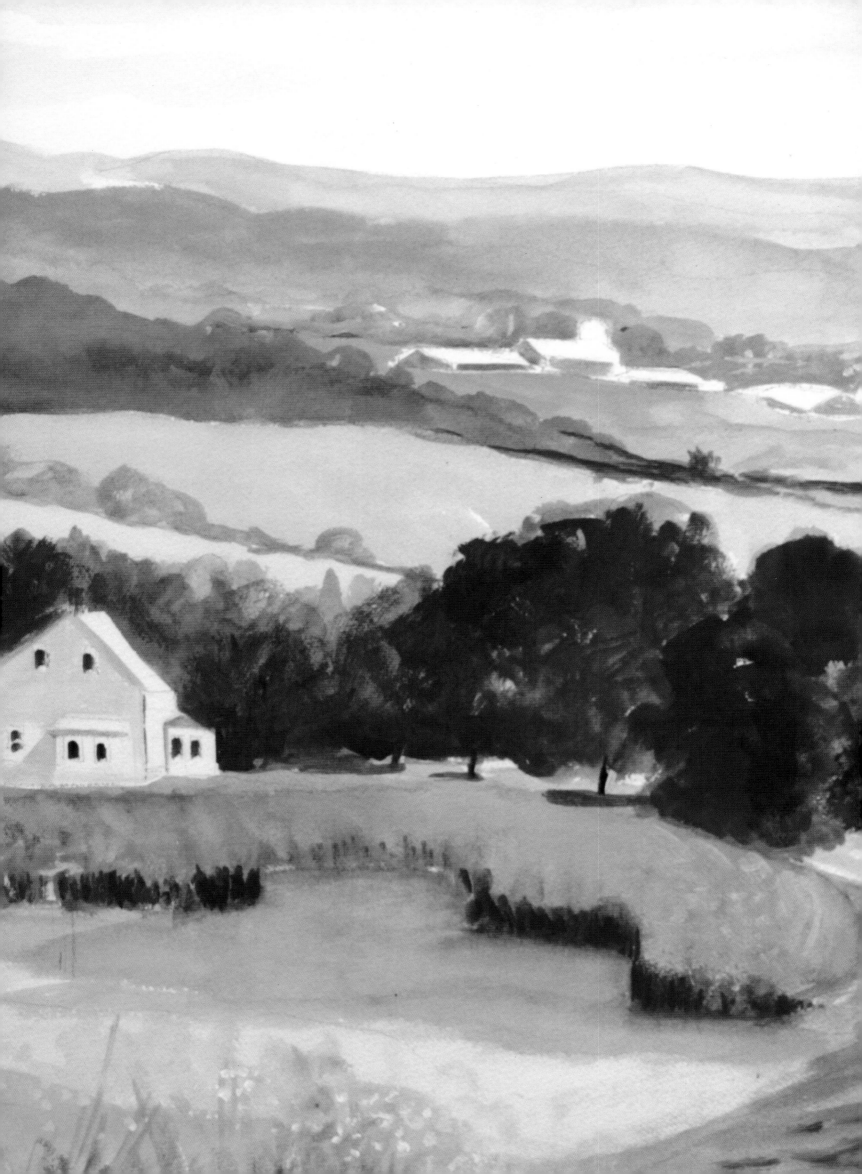

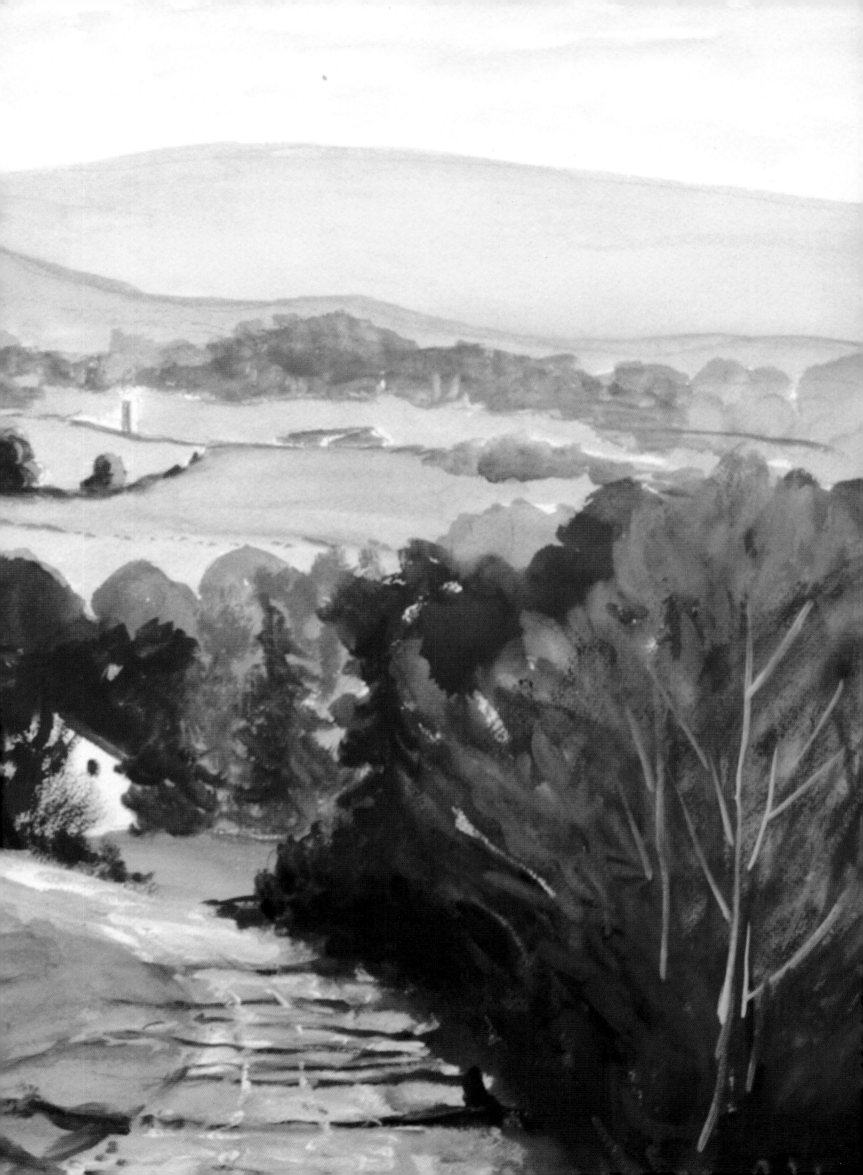

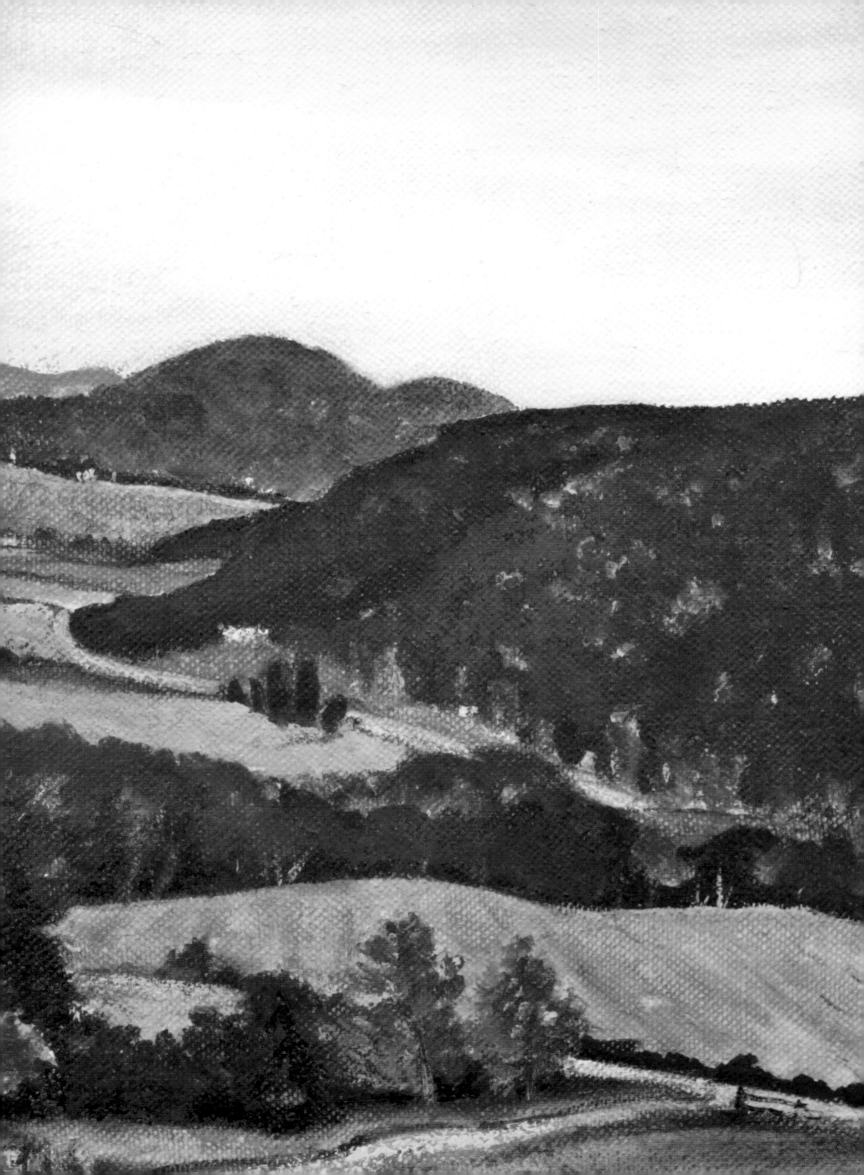

CHAPTER 5
Salem

The Osoma Valley is fertile land with a high water table. The first settlers came from Pelham, Massachusetts, in 1761, led by James Turner and Joshua Conkey. They called their little settlement "White Creek" because of the white quartz pebbles in the stream. Irish immigrants under the leadership of the Reverend Dr. Thomas Clark arrived here in 1764 and decided the place should be called "New Perth." Each group had its own separate Presbyterian church and its own name for the town. United by their common opposition to the British during the American Revolution, the two groups managed to agree to call the town Salem, meaning "peace," in 1788.

The principal streets, Broadway and Main, are lined with fine, old houses, mostly from the 1800s. Two severe fires in 1840 and one in 1870 took away many of the earlier buildings. These disasters led to the improvement of the fire brigade, and the Union Engine House, built in 1866, is still in use. A grand, brick house on East Broadway, built about 1810, was the home of the daughter-in-law and grandchildren of the renowned ornithologist John James Audubon. Like many of the elegant houses along this tree-shaded street, it has lovely grounds with well-planted flower gardens. The former Washington County courthouse at the end of Broadway is still in the process of restoration. It has the severe look of a public building, complemented by a grim jail in back with thick, steel bars painted an institutional gray. The empty cells are unguarded.

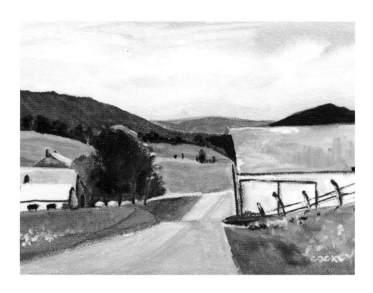

Back Road No. 1
2007; gouache on canvas;
5 x 7 in.
We were on our way to Vermont, taking the back way. In some instances, the hills and valleys were so deep that we couldn't see over the top of the road. Neil Adams, the owner of the farm in this painting, calls his place the Up and Over Farm.

Anyone driving through the eastern part of Washington county and into Vermont will be impressed by the distinctive shape of the hills, with steep sides and round tops. This hilly country lends itself well to sheep and alpaca farming, and some farmers have fit into the niche markets for organic lamb, organic goat cheese, and even sheep milk.

Author and sheep farmer Jon Katz lives near West Hebron, not far from Salem. Following his bliss (to borrow a phrase from Joseph Campbell), this New Jersey suburbanite moved to the country while his wife stayed behind in the big city and continued her urban career. Husband and wife live in parallel universes.

Jon Katz came to sheep farming backward. Most sheepherders decide to raise sheep and then acquire dogs. Katz is a dog lover who got sheep so that the dogs would have something to do. It's like the reason Elizabeth bought a second Pekinese, so that the first one would be "psychologically sound." She was right, of course; having a beta dog to beat up has done Piggy a world of good. Rosa Lee, for her part, has settled contentedly into the role of neurotic underdog. Sheep

Going East to Salem
2006; gouache on canvas;
11 x 14 in.
Ken Flagg took the photo from the top of Dillon's Hill in East Greenwich, and then I painted it. It was early fall, and the leaves had just started to turn color, so the contrasts between the reds and the golds and the dark blue mountains were incredible. The road in the painting eventually leads into the town of Salem.

dogs need a herd of sheep for the same reason: their mental health demands it. How the sheep feel is another matter. One likes to think that being chased but not eaten by a wolf-like dog gives a sheep the sense that the world is running according to plan.

The dicey economics of agriculture create an environment in which a second job, whether it be writing books, driving a bus, plowing roads, or repairing cars, is a necessity for most of those who love the farming life. Another necessity in these parts is tolerance for the cold. Winter temperatures around here fall well below zero; ten or twenty below is not unusual, and that's without the wind chill. The solution to the problem of cold is to come here only in summer. How to cope with ticks is also a frequent topic of discussion. The solution to the tick problem is to come only in the winter.

The hummocky hills near the Vermont border are so distinctive that you can't look at them without wondering how they got that way. Geologists have been wondering the same thing for a long time, and in fact, this region was one of the first to be explained by the new theory of plate tectonics in 1969 and 1970. It is now thought that in the Ordovician period, between about 460 and 436 million years ago, two plates collided here, generating tremendous heat and pressure and mashing and warping the rocks into twisted schists and gnarled gneisses. The plate to the West, known as Laurentia, is the North American craton—a thick, sturdy chunk of continental crust that has held together even as the continents and super continents have split and merged over hundreds of millions of years. To the East was the plate forming the floor of the Iapetus Ocean. The Iapetus plate drove downward at the edge of the massive Laurentian plate, heating and deforming the rock layers and thrusting up the Taconic mountain

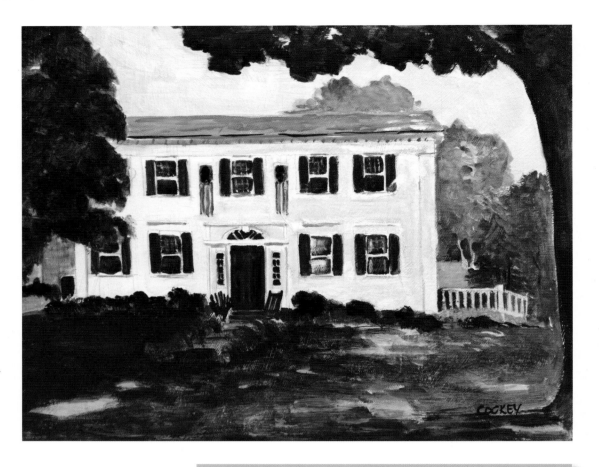

Flagg House
2007; gouache on canvas;
16 x 20 in.
Ken and Judy Flagg's Federal-style house was built in 1787. The builder, Walter Martin, constructed several other homes at Fitches Point where the Battenkill joins the Black Creek River. Today, the home still maintains its impressive facade.

range. The roiled earth sent up off-shore volcanoes along the line of the collision. As the plates continued moving, the new volcanic rock was forced up against the unyielding shelf of Laurentia and buckled, heated, and recrystallized. A few hundred million years of the washing of water and grinding of glaciers reshaped the landscape, leaving round-topped hills of the hardest hunks of metamorphic rock.

A notable product of this region is the slate that was created from softer shale by the forces that threw up the Taconic range. Slate of many colors has been hewn from the hills north of Salem for centuries. Granville is famous for its beautiful, red slate, the reddest in the world. Today, many of the old quarries lie abandoned. Other, cheaper roof coverings have taken most of the market, since it's hard to be efficient in slate mining. The quarries lose about 85 percent of their brittle product in blasting, splitting, and culling. In Vermont,

the wastage is said to be 95 percent. Still, there is a continuing demand for slate floor tiles and of course for replacement slates for all those old roofs. Around here, almost all the old buildings, even lowly sheds, have beautiful, slate roofs. Some are sway-backed, and some appear to defy gravity atop rickety old barns, but the roofs invariably look to be the most durable part of the building. Many are over two hundred years old.

Slate was not the only product of this part of Washington County. The Village of Salem, like many other sleepy country towns in upstate New York, still holds reminders of its active industrial past. The Shirt Shop is a fifteen-thousand-square-foot, red brick factory building on the south edge of town. This fine specimen of nineteenth-century industrial architecture sits idle and vacant, waiting for some intrepid latter-day

Bedlam Farm
2007; gouache on canvas;
16 x 20 in.

Author Jon Katz owns and operates a small farm on the outskirts of Salem, in a little hamlet called Shushan. The day that I visited him, he rounded up his livestock with the help of his border collie, Rose. But as he made his way down the driveway with the flock, I couldn't help but turn my attention to the landscape in front of us.

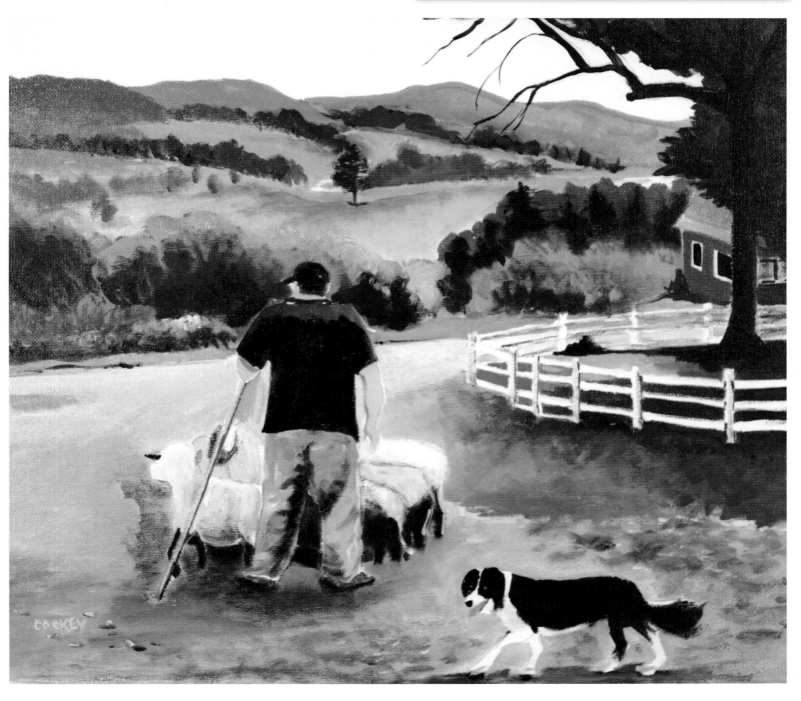

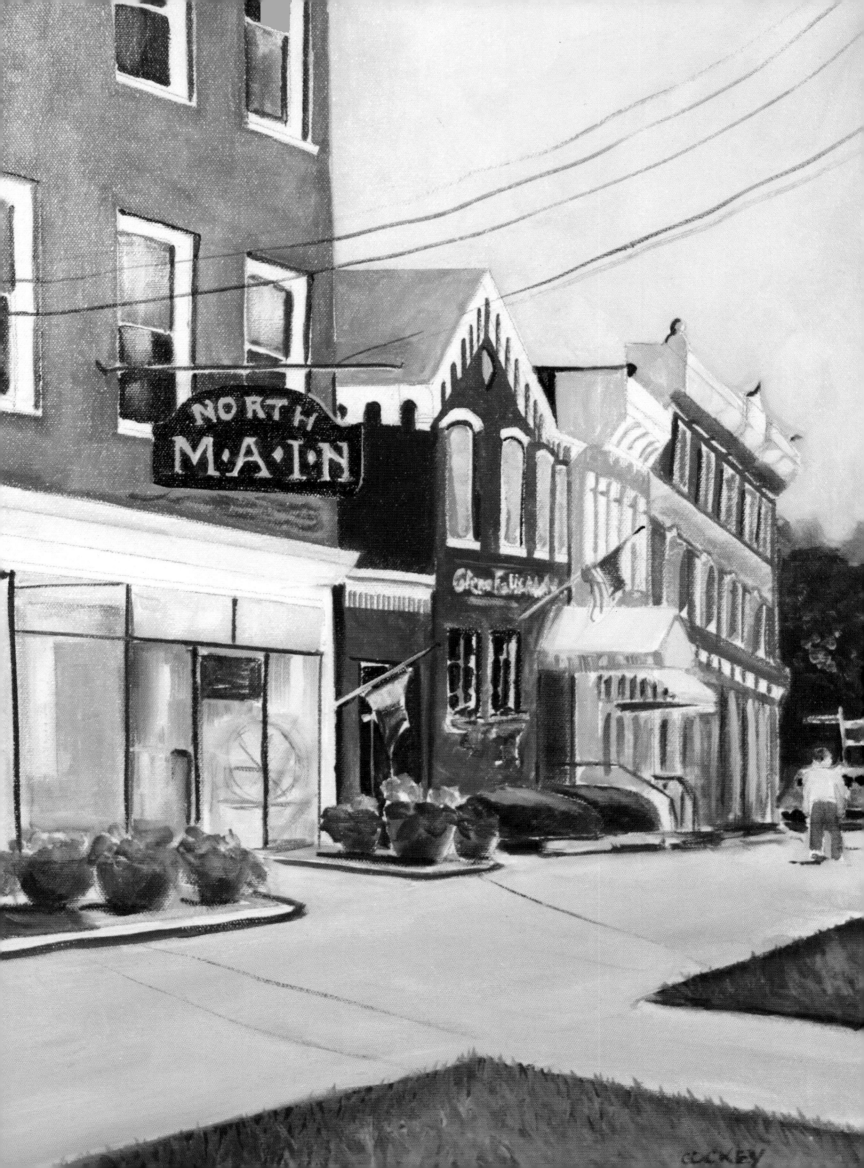

North Main Street, Salem
2007; gouache on canvas;
16 x 20 in.

I took numerous photos of the main street from both sides. And I must say that it was difficult to decide which side of the street to paint because of the beauty and finesse of the old buildings. The word "quaint" comes to mind, but it's more than that. It's the idea that in these same buildings, I once visited my great-aunt who lived in an apartment on the second floor, over the hardware store. I gobbled ice cream sodas in the old pharmacy on the corner with my mother on our way back from Granville. How does one paint a picture of a street that should really be a story?

Another variety of early industrial architecture well represented in Washington County is the covered bridge. The one in Elizabeth's painting is at Eagleville and was built in 1858. Local children love to swim in the Battenkill under this bridge. In obedience to long-standing tradition, they occasionally made holes in the side of the bridge so that they could jump into the river. Robert McIntosh notes in his detailed history that in the past, so-called "inspection doors" and "ventilation ports" were installed to accommodate jumpers and limit the damage. This solution was much too sensible to last in our litigation-conscious age, and today the sides of the bridge are solid. Elizabeth has fond memories of bringing her older son here to swim when he was little, though she attests that she never kicked any holes in the bridge. In those days, the boards were weathered gray. We both think that the red paint is an improvement.

pioneer to wade into the thickets of taxes and regulations and restore it to productive activity. In a simpler time, a grist mill and plaster mill stood at this site. A pleasant place now, it must have seemed like Eden back then, with the clear stream flowing by. Unlike the powerful falls of the Battenkill in Greenwich, the little stream that the Indians called Osoma, meaning "white creek," carries too little water to run a large mill. Around 1837, the southwest wing of the present building, then called Salem Steam Works, was constructed. Later, in 1899, John M. Williams completed the structure. Over the years, the textile mill turned out shirt collars, sportswear, and sleepwear.

Audubon's House
2007; gouache on canvas;
11 x 14 in.

This Federal-style house, built circa 1810, was occupied by the daughter-in-law and grandchildren of ornithologist John J. Audubon. The expansive lawns and gardens reaching to the brook behind the house make it distinctive.

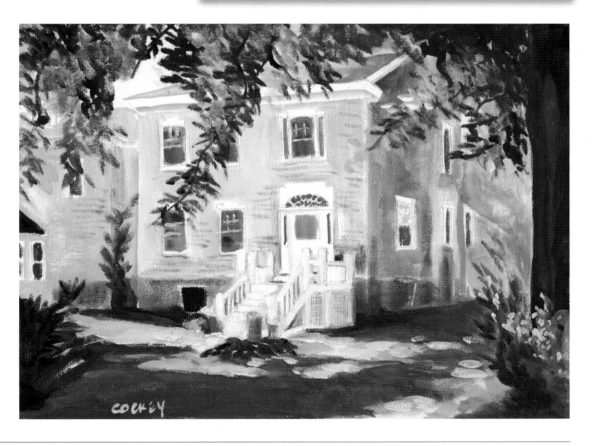

Over the years since Elizabeth's son swam here, Eagleville Bridge has needed more than mere paint. In 1977, flood waters washed out the east abutment (seen across the river in the painting), and the end of the bridge twisted downward. Amazingly, the hundred-foot span was raised back into position with only minor damage. The wooden lattice truss patented in 1820 by Ithiel Town had proved its strength and flexibility.

Ithiel Town was born in Thompson, Connecticut, on October 3, 1784. Most of his life's work was architecture. With an eye for the classical styles, Town designed buildings ranging from Greek Revival to Gothic. His most monumental design was for the massive stone aqueduct that carried the Chesapeake and Ohio canal across the Potomac River just above Washington, D.C. (The aqueduct survived the efforts of Confederate saboteurs but could not resist the river; only the piers and abutments remain.) On the whole, he disdained innovation in architecture, but he is best known for the brilliantly novel framework that is concealed by the plain sheathing boards of many of America's covered bridges.

Inside the wall of Eagleville Bridge is a web of overlapping diagonal planks, laid up like a garden trellis and pegged together at each crossing with hardwood pins called treenails or "trunnels." The resulting tensile integrity anticipates the work of Buckminster Fuller. Construction of a Town truss was an easy job for ordinary work crews. There was no need for tedious chiseling of mortises and tenons, and the light planks were easier to handle than heavy timbers. Celebrated for his contributions to American architecture and enriched by his truss patent, Ithiel Town died on June 13, 1844. His bridges live on.

Another bridge of the same type, built in the same year, 1858, still spans the Battenkill at Shushan. Shushan Bridge is 161 feet long and weighs about eighty tons. In 1962, the county erected a steel bridge at this site, and the western end of the old covered bridge was swung northward onto a pedestal so that it was no longer supported by a pier in midstream. Still the faithful, old structure stood, unused and untended, until a roof leak led to decay, and the bridge nearly collapsed. At the last moment, a citizens' group led by John Rich and Carleton Foster restored the bridge and turned it into a museum of antique farm implements, a favorite place to stop on a summer day and see how things used to be done.

New England Presbyterian Church
2007; gouache on canvas;
11 x 14 in.

The brick church was first constructed in 1774 and was used as a barracks and then a fort. A fire destroyed the building, and it was rebuilt in 1836. The present Greek Revival–style building with New England meeting-house steeple and belfry is now privately owned and used as a summer theatre. Most know it as the Ft. Salem Theatre.

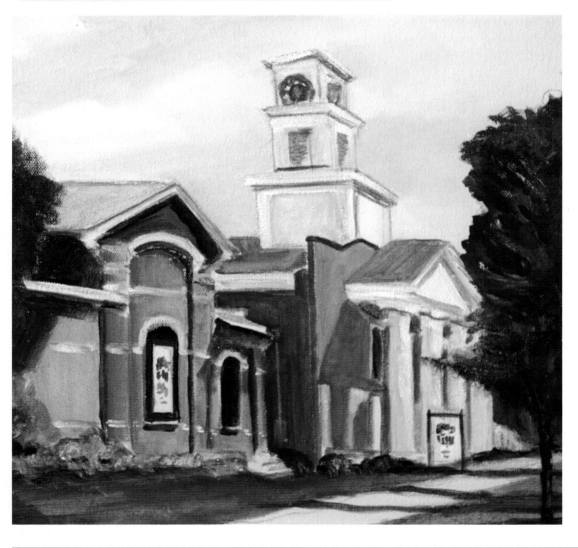

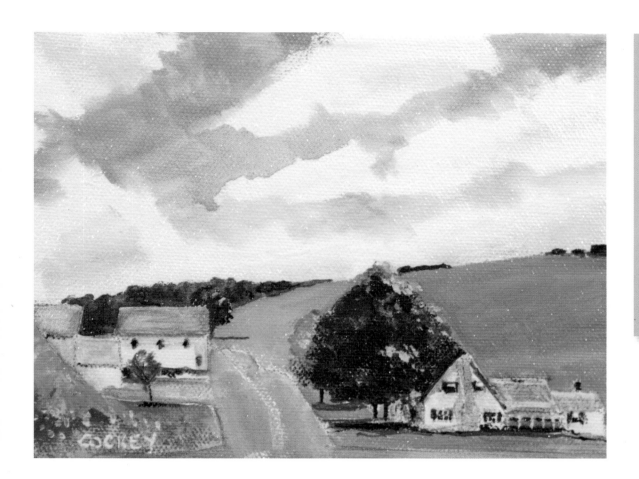

Back Road No. 2
2007; gouache on canvas;
5 x 7 in.

This scene is of the same farm coming from the "other way" on my way back into Salem (see Back Road No. 1). As you can see, I was completely mesmerized by the rolling countryside and the way the clouds came down to touch the horizon.

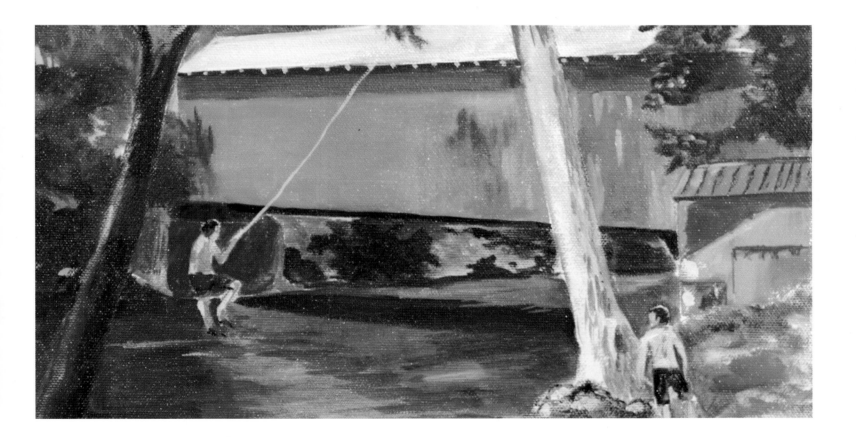

Covered Bridge
2007; gouache on canvas;
9 x 12 in.

Located just outside of Salem in a small hamlet called Eagleville, this covered bridge is still in use today. I took my children there once to swim just below the bridge in the Battenkill River and to swing out on the rope as the two boys were doing the day I visited.

There is a romance to covered bridges—they take us back to a slower-paced era of horses and carriages. Some folks used to call them "kissing bridges" because it was dark and private inside. The movie and best-selling novel *The Bridges of Madison County* by Robert James Waller considerably enhanced this notion of covered bridges as architectural mistletoe. Yet the covering of the bridge was entirely practical. Untreated wood exposed to the weather in this rainy part of the country has a useful life of no more than ten or

fifteen years. Protected from the weather, the wood will hold up for centuries.

As for me, I can't look at an enclosed bridge without thinking of Edgar Allen Poe's short story "Never Bet the Devil Your Head," a cautionary tale about a chap named Toby Dammit who has the unfortunate habit of supporting his assertions with the offer of a wager. He and the narrator walk across a covered bridge with a turnstile at the far end. Toby announces that he is going to jump over the turnstile, but the narrator expresses doubt that he can clear it. Piqued, Toby says that he'll bet the devil his head that he can make the jump. Of course, he loses his head and the bet simultaneously because of a structural feature that appears to be absent from the bridges near Salem. At least, it *appears* to be absent, but be warned!

On the subject of architecture, I have so far omitted any discussion of churches. There are simply so many beautiful churches in all of our beloved towns that it is impossible to

First United Presbyterian Church
2007; gouache on canvas;
16 x 20 in.

Salem was founded by 140 Presbyterians from Ballibay, Ireland, and this church was built for that congregation in 1797 by Walter Martin. This is one of the oldest churches north of Albany, and when I first saw it, what came into my head was a phrase from my church hymnal: "Praise God for whom all blessings flow." It is a very grand place.

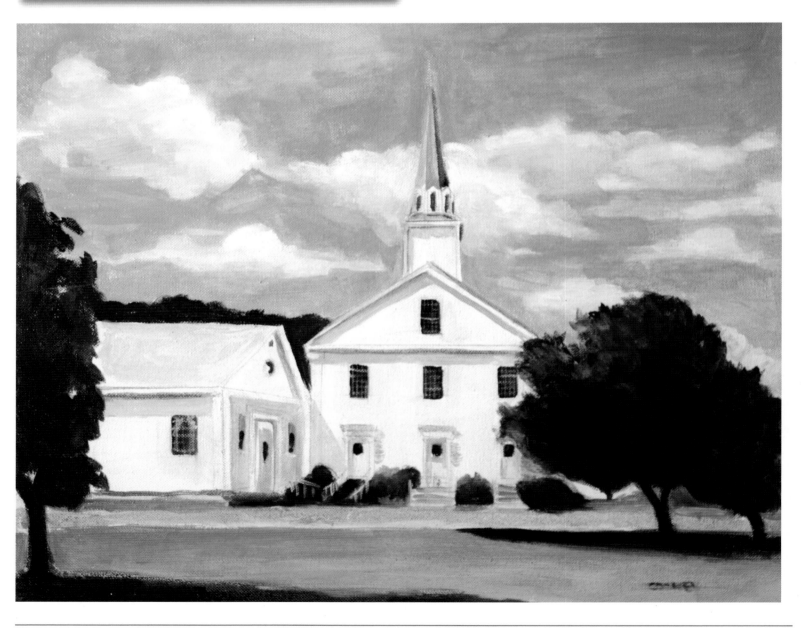

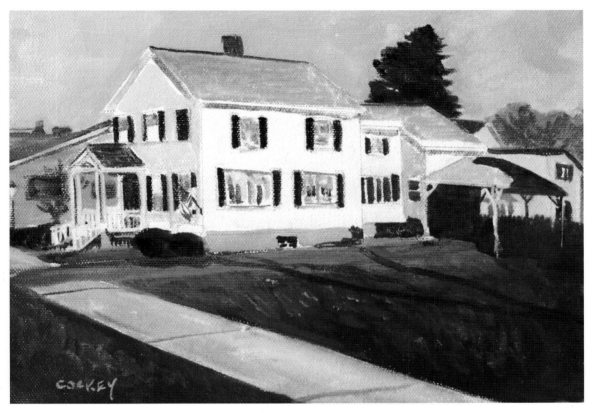

Barber House
2007; gouache on canvas;
8 x 10 in.

My cousin Jack Barber and his wife, Barbara, live in this Co-lonial-style house on Broadway, right down the street from the First United Presbyterian Church. He said he has fallen off the house a couple of times in January while shoveling snow off the roof. Cousin Barbara says it's because he's clum-sy and not because of the snow. Either way they are fond of telling me that if you can survive a winter in upstate New York, you can probably get through most anything.

over the loss of a dear lady who, as a voice teacher, had brought cheer and inspira-tion to students of all ages. Ripples of kindness had spread out from her to touch everyone. The spacious eigh-teenth-century church was packed. Even the balconies were filled to capacity. As we sat down with our cousins in one of the old-fashioned, gated pews, I marveled at the brightness of the place. This is one of the classic churches of the Enlightenment, with clear glass panes in tall windows. As much as I like stained glass, there is equal inspiration in these austere, colonial-style windows. Looking out, you can see the sky, as if gazing up to heaven. In churches like this one, the founders of our repub-lic met to pray for the success of the revolution and to give thanks for victory.

Music was playing. A female minister appeared in the front of the church, and my thoughts were snapped back into the present century. Children in the congregation stood to tell how their teacher had touched their lives. Their voices, even though choked with sorrow, carried clearly without amplifica-tion. Good church design, I thought, although those voice lessons must have helped. What a fine place to gather with good people and share life's joys and burdens!

know where to begin. The church is at the center of each community, its spire a call to remember that we live to God. The multiplicity of churches tells a story of disagreement and toleration, of varying creeds and the rejection of creeds, of immigrants from different countries confessing the same creed but choosing to build separate houses of worship, and of people from widely varied backgrounds worshiping before the same altar. This fraught history is beyond the scope of our book. But I do want to describe, as a random sample, a recent church service in Salem.

The Saturday before Christmas of 2007, Elizabeth and I attended a memorial service at the First United Presbyterian Church. There was snow and ice on the ground, but the chill in the air was also the deep sadness of the entire community

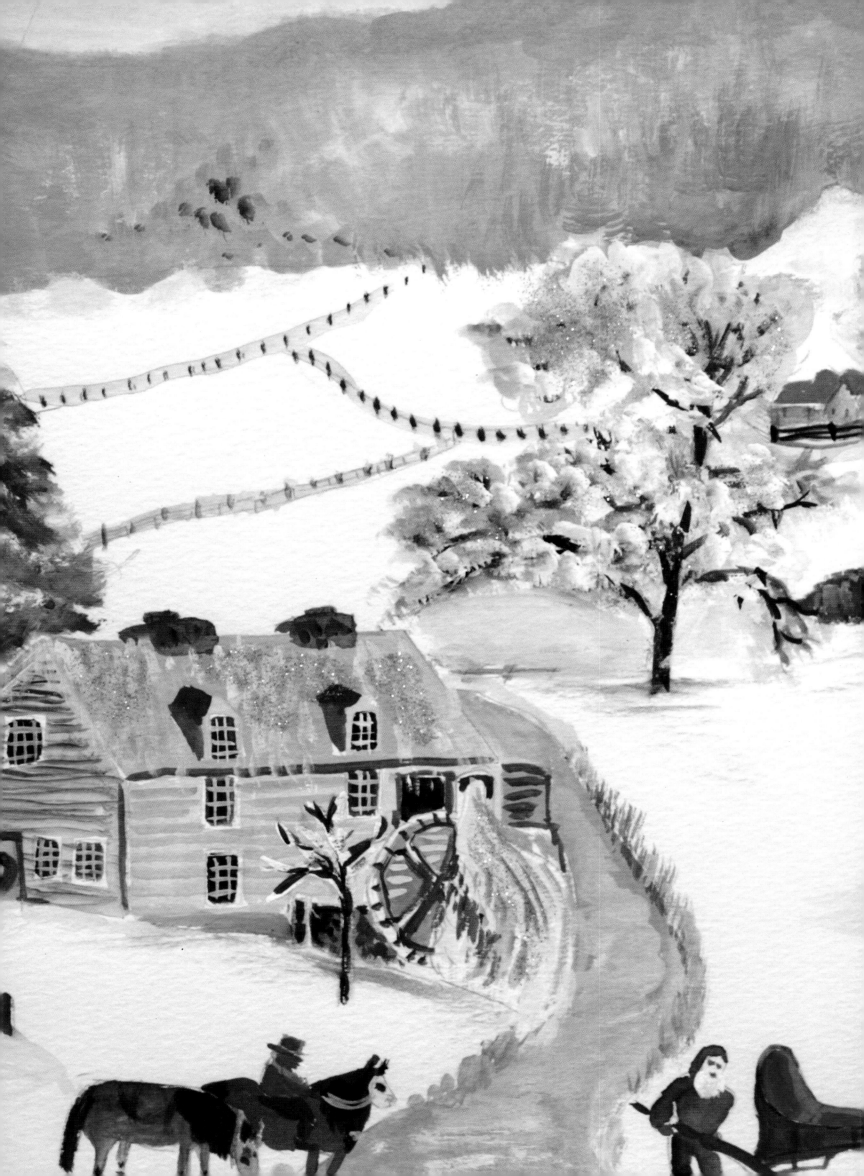

CHAPTER 6
Cambridge

Even the casual visitor to the village of Cambridge can see that this is a very old place of human habitation. Many of the houses, both large and small, are from the late eighteenth century. Nineteenth-century buildings along the main street range in style from the neoclassical Rice Mansion (huge, fluted Ionic columns) to the 1880 Hubbard Hall (dark Victorian, with a tower that looks as if it ought to be haunted) to the 1885 Cambridge Hotel (airy, wooden arches).

Through the middle of town and intersecting the road at a right angle runs the railroad track. The old station buildings have fallen into disrepair with the demise of the railroad, but the community is making excellent progress toward restoring them. It appears to me that this beautiful, historic village has an unusual opportunity to revive an unspoiled town center that once huddled around the rails. A superb farmers' market is tented out between the tracks and the hotel.

During our last visit to the farmers' market, Elizabeth bought eggs. Our friend Paula sampled some cheese made by Elizabeth Porter in Argyle—"High Rock" cheese, "like a Gruyère," the vendor explained. One bite and I was hooked. Cheese is always at its best when eaten outdoors on a warm day in an attractive place, but this was more complex and flavorful than any Gruyère I had ever tasted, even in the Swiss town of

Grandma Moses Revisited
2004; watercolor and glitter;
16 x 20 in.

I am very fond of Grandma Moses's paintings because she was able to depict the scenery and the lifestyle of the place better than anyone else, before or since. Those who live here immediately recognize Washington County and the surrounding foothills of Vermont in her paintings. Born in 1860, she lived to be 101 years old, and she painted up until the time of her death. Her family still reside in the area near Cambridge today, and her great-grandson, Will Moses, paints in the same style.

the same name. Elizabeth bought an extra block. "We'll go through this in no time!"

It seems odd that so many items in the grocery stores are brought from far away so that they can be sold in a farming community. Lately, there has been an official effort to promote regional businesses, and one of our proudest possessions is a white coffee mug bearing the bold exhortation, "BUY LOCAL!" above a dark green silhouette of houses, trees, churches, and cows. Below the image are the words, "The Towns and Villages of the Battenkill Valley." Ironically, on the bottom of the mug is a sticker that says, "Made in Taiwan." Well, you do the best you can in a global economy.

After browsing through the antique shops near the old station, we drove up the hill to look at the Mary McClellan Hospital, an attractive, Georgian-style, red brick building now appearing rather forlorn, with an ill-conceived box-like brick addition in front. Down to fifteen beds and plagued by financial difficulties and the limitations of an old building, the hospital closed in May of 2003. Weeds grow up through the cracks in the concrete parking lot. The trees in the valley are a mix of darkest green and sunny yellow; distant mountains show pale blue with summer haze.

According to legend, the first white men to see this valley passed through in 1540. Jean Fonteneau, a.k.a. Allefonsce

Rice Mansion
2007; gouache on canvas;
11 x 14 in.

This Greek Revival–style mansion is located on Main Street in Cambridge. Recently restored to its original grandeur as a bed-and-breakfast, it makes a grand impression as you drive through the middle of town.

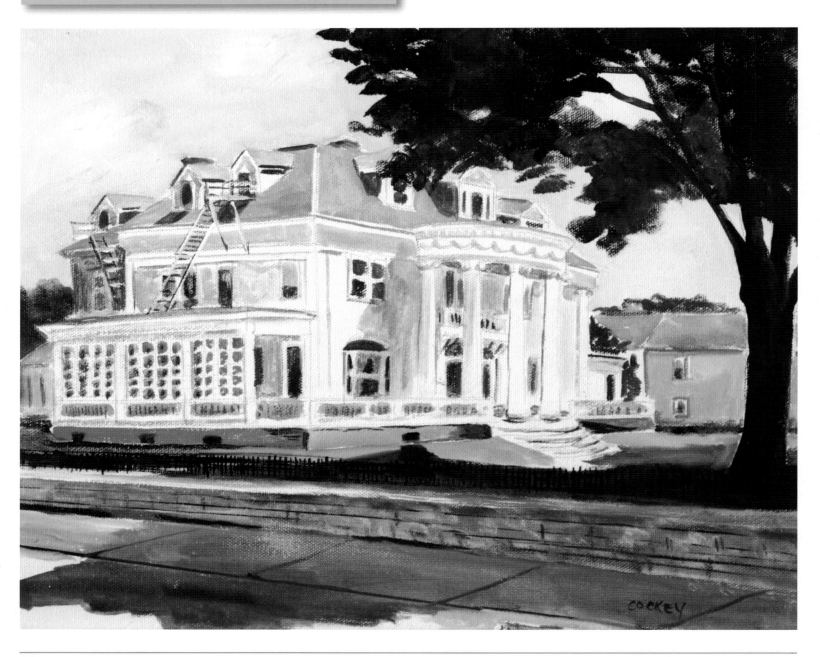

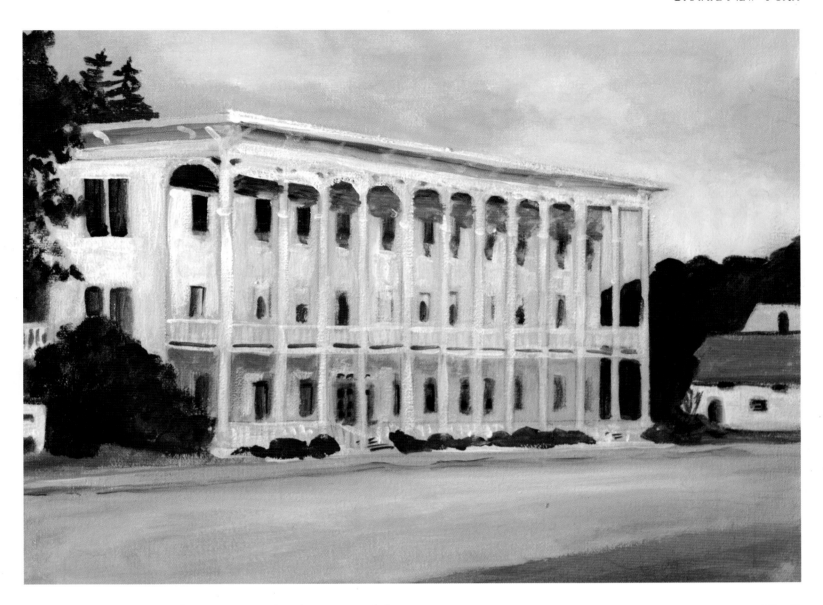

de Saintonge, and his little party are said to have crossed the Owl Kill near this place on his way to the junction of the Walloomsac and the Hoosic, where they set up a Jesuit chapel named St. Croix. They followed well-worn Indian trails, where native people had walked for seven millennia. An east-west trail from the Connecticut Valley to the Hudson intersected a north-south trail along the course of the turnpike (Route 22). Here was the home of the Owl, the wise, seventeenth-century chief of the Hoosac, a Mohican tribe. At the confluence of the Owl Kill and the Hoosic was the meeting-place and altar where the Owl gave his famous orations. The Mohicans' tenuous hold on these lands, long contested by their deadly enemies the Mohawks, was further challenged by the Dutch colonial administration's Hoosick Patent of 1688, which included part of the southern end of the Town of Cambridge.

Indian raiding parties made permanent settlement here impossible until after the conclusion of the French and Indian War. Then, families from Colrain, Massachusetts, and Hebron,

Cambridge Hotel
2007; gouache on canvas;
11 x 14 in.

The historic hotel is the original home of pie à la mode. Recently revitalized and upgraded to accommodate even the most discerning guest, this hotel is located in the heart of downtown Cambridge. It is certainly an inviting place to stay, and it has a restaurant that really does serve what it's famous for.

Connecticut, moved here and began constructing the symmetrical clapboard houses that survive to this day. One notable early settler and patriot, John Weir, was indispensable to the American victory at the Battle of Bennington. Weir had been a scout for Sir William Johnson and knew the perils of the frontier. Alerted by his in-laws living on the Ondawa Trail, he had advance notice of the march of British General Baum and his marauding Indians toward Cambridge and Bennington. Hastening to find General John Stark in Vermont, Weir man-

aged to warn the patriot forces in time for Stark and Seth Warner to move to protect Bennington.

The close relationship between the people of Cambridge and those of the New Hampshire Grants (proto-Vermont) provides an interesting footnote to the history of this region. Vermont had declared itself an independent republic in 1777. Cambridge and some surrounding districts, feeling a stron-ger bond of kinship and philosophical compatibility with the independent Vermonters than with the big landholders of New York, held a convention on May 15, 1781, to declare them-selves part of the Republic of Vermont. Secession remorse set in quickly, however, and Cambridge returned to New York wiser but no sadder. What a pity it is that Lincoln didn't give the Confederacy time to have second thoughts.

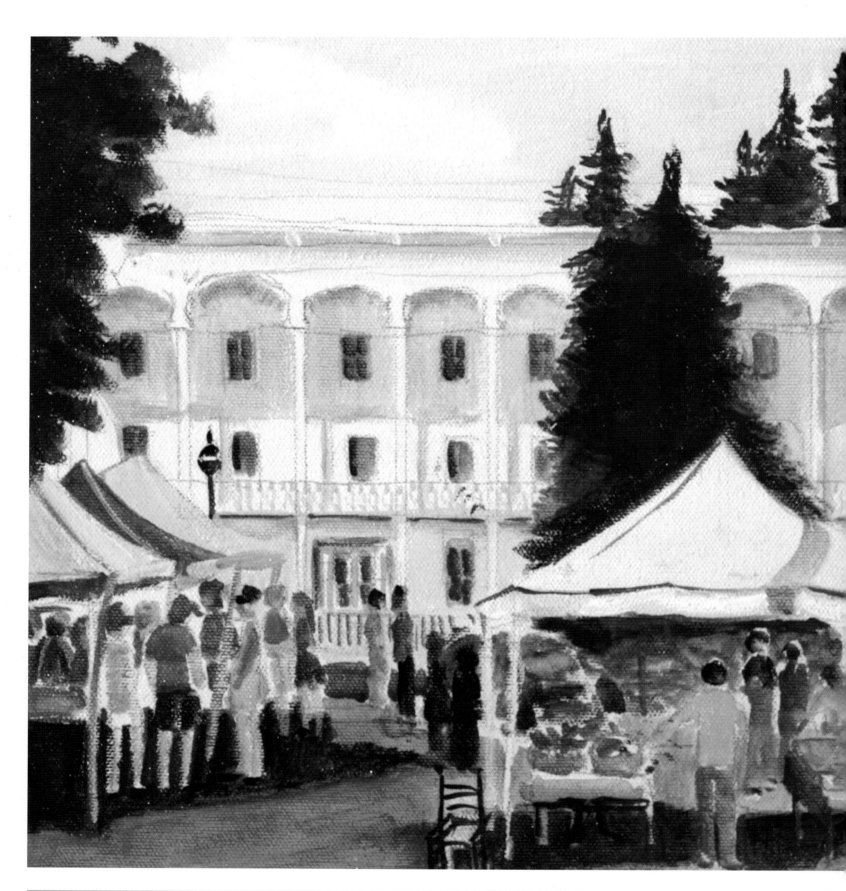

The cultivation of flax and herding of sheep brought middling prosperity to Cambridge, but the railroads brought commerce and helped build the wealth of the Jerome B. Rice Seed and the Cambridge Steel Plow companies. The great swamp from which the Owl Kill flows was filled in to permit the construction of the seed-packing plant, the Cambridge Union School, and the library building. Today, the big industries are gone, but the town is reviving as a tourist destination.

The Village of Cambridge lies within the Towns of Cambridge and White Creek. The best known resident of the Town of White Creek was Anna Mary Moses, known to the world as Grandma. An inspiration to retirees everywhere, Grandma Moses took up painting in her seventies after arthritis compelled her to give up embroidery. Her "primitive" paintings show a rich abundance of detail, and what they lack in perspective, they more than compensate in color and activity. She obviously had fun; she even put glitter on the snow in winter scenes. Today, Will Moses lives at the family farm in Eagle Bridge and carries on the folk art tradition. Look at the shape of the hills in their paintings, and you'll recognize the beautiful country around Cambridge. Elizabeth always says, "Art makes you better." Grandma Moses is a case in point. Not only did the quality of her work improve over the years, but she lived to the age of 101. Was art the secret of her longevity? Of course!

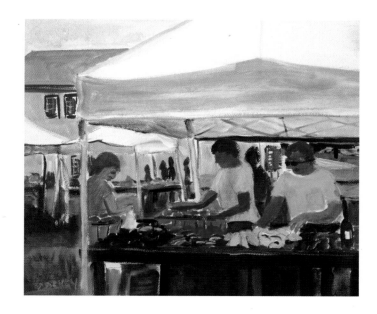

Farmers' Market
2007; gouache on canvas and detail;
11 x 14 in. (opposite)
9 x 12 in. (top)

The farmers' market is open on Saturday mornings in Cambridge and is hosted by local merchants, farmers selling fresh produce, and skilled craftsmen showing off their wares. We strolled around the grounds for nearly an hour, fascinated by the variety of fresh vegetables, farm eggs, local cheeses, and of course the "locals." Nestled between the Cambridge Hotel and the antique train station, the whole scene was a bit like going back to yesteryear. It was all so simple then.

Older Trains Stopped Here

2007; gouache on canvas; 9 x 12 in.

Recently restored, the train station is really a tribute to days gone by. Some of the original tracks are still there, mostly hidden from view now by the tall grasses and weeds that have grown up along the side of the building. It was our understanding that there is more restoration to come in the interior. We just couldn't help but wonder what it must have been like to board a train here back in the old days.

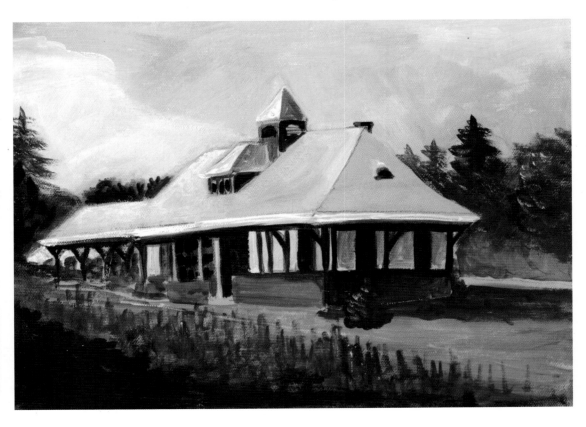

Once in a while, someone finds an original Grandma Moses painting in a local antique store. Someone we know (and we are sworn to secrecy as to this person's identity) bought one painted on cardboard for seven dollars. It has been appraised for tens of thousands. Even if no such extraordinary bargains turn up, poking around in antique stores is an endless source of enjoyment in Cambridge and the other small towns. The material culture of the past is best appreciated first hand.

One of the most delightful features of old objects is that our ancestors actually repaired things. Yes, incredible as it seems, if something broke, people would sooner fix it than throw it away. Look at old flat irons, for example, those heavy, solid irons cast in one piece with the handle. When the handles broke off, the iron would be mended by a blacksmith, who drilled a hole in the middle of it and welded a loop of iron or mild steel into the hole. These re-handled irons charm

One More Victorian House

2007; gouache on canvas; 9 x 12 in.

Like so many towns in upstate New York, Cambridge has a wealth of historic homes dating back from several architectural periods: Federal, Colonial, and Victorian. As I was waiting for Barton to make his way up the street from the farmers' market, I noticed this beautiful home across the street from the train station. I was fascinated by the "matching" barns out back, tucked nicely in between the gardens and the main house.

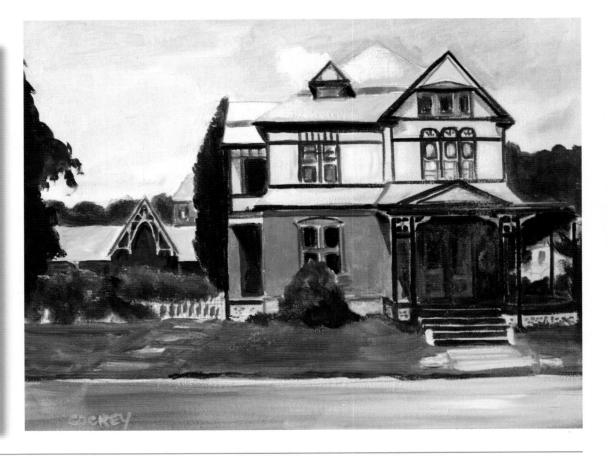

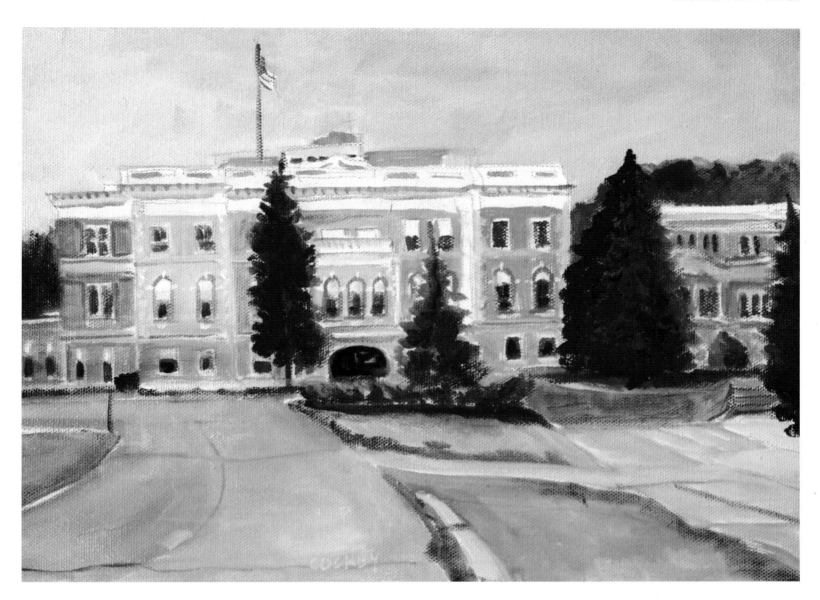

me more than intact ones because they bespeak a culture of thrift that the modern age needs to rediscover.

Another item that turns up in these parts is the patent-medicine bottle. These old bottles, of varying tint but most often light blue, are to be found all over the country, but they occur in remarkable profusion in this area. Some have the name of the medicine molded into the glass. Mandrake bitters, jaundice bitters, and swamp root appear to have been popular. With any luck, progress will make our present-day remedies seem just as quaint to our descendants. And save those child-proof caps. Someone a hundred years from now will get a good chuckle out of those.

Sometimes old postcards turn up with pictures of local features from a hundred years ago. This book includes one showing the front of the Rice mansion. Most of the street scenes are still recognizable. Some buildings have burned down, like the old Eagle Bridge Hotel in Grandma Moses' hometown and the White Swan Hotel in the center of Greenwich; but

Mary McClellan Hospital
2007; gouache on canvas;
9 x 12 in.

The old hospital buildings sit stoically on the highest ground in Cambridge, overlooking the Vermont mountains, which lie to the east. My mother worked as a registered nurse there, and many of my friends and family members were born at Mary McClellan. A few of us also received medical attention there; it was the closest place around. Since the 1970s, things have changed, and the hospital was unable to remain economically solvent. Today it still serves the community, but in a different way; it is now a nursing home.

on the whole, things are pretty much as they were. So many people speak of their hometowns in the past tense, swallowed up by the sprawl of large cities. Blessed are they who really can come home again some day.

CHAPTER 7
Day Trips

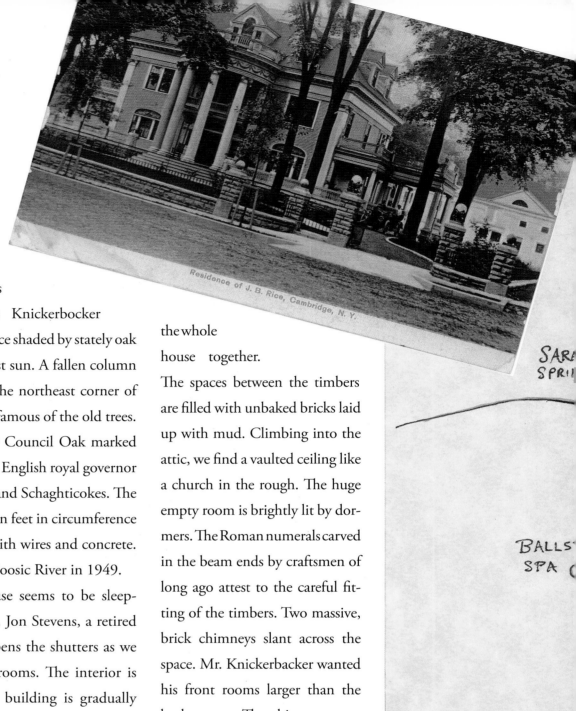

Residence of J. B. Rice, Cambridge, N.Y.

THE KNICKERBOCKER MANSION

In the flat bottomland between Schaghticoke and the Hudson stands the eighteenth-century, Flemish-style Knickerbocker Mansion, surrounded by farm fields. Once shaded by stately oak trees, the house now bakes in the August sun. A fallen column of concrete like a giant fossil bone in the northeast corner of the lawn is all that remains of the most famous of the old trees. Planted in 1676, the Wittangemote or Council Oak marked the signing of peace treaties between the English royal governor Andros and the chiefs of the Mohicans and Schaghticokes. The magnificent white oak tree grew to fifteen feet in circumference and in its last years was kept together with wires and concrete. It finally succumbed to a flood of the Hoosic River in 1949.

With shuttered windows, the house seems to be sleeping or closing its eyes against the glare. Jon Stevens, a retired scientist, genealogist, and historian, opens the shutters as we walk with him through the deserted rooms. The interior is cool and dark. Long abandoned, the building is gradually being restored by dedicated volunteers. The front parlor has some new paint and plaster and wallpaper just like one of the originals. Details of faux wood grain on the door between the parlor and the hall are emerging pixel by pixel from behind layers of paint as Jon patiently chips at it with dental tools.

The unfinished state of restoration is much more interesting than a seamless, Williamsburg-perfect product. Here you can see the post-and-beam construction of the walls and roof. Cut, mortised, numbered, and pegged, the sturdy wooden frame holds the whole house together.

The spaces between the timbers are filled with unbaked bricks laid up with mud. Climbing into the attic, we find a vaulted ceiling like a church in the rough. The huge empty room is brightly lit by dormers. The Roman numerals carved in the beam ends by craftsmen of long ago attest to the careful fitting of the timbers. Two massive, brick chimneys slant across the space. Mr. Knickerbacker wanted his front rooms larger than the back rooms. The chimneys consequently have to slant to emerge in the middle of the roof ridge.

Peering out of the dormers, we can see that this little round valley is surrounded by forested hills. The Hoosic River meanders through on its way to the Hudson. Supposedly, the name of the Town of Schaghticoke comes from an Indian word meaning "meeting of the waters." This translation strikes me as no more dubious than any of the others and will serve well enough. Apparently the Indians considered the confluence of the Hoosic and Tomhannock a special place, as this valley was chosen for the great peace-tree planting.

Whatever the accuracy of the translation of the curious name of the Town, the name of the distinguished family that lived in

The World around Greenwich

The map, approximately to scale, shows most of the sites mentioned in *Upstate New York*. This little universe retains much of the charm of an earlier time. The antique postcard from about 1906 depicts the Rice Mansion in Cambridge, looking much the same as it does today.

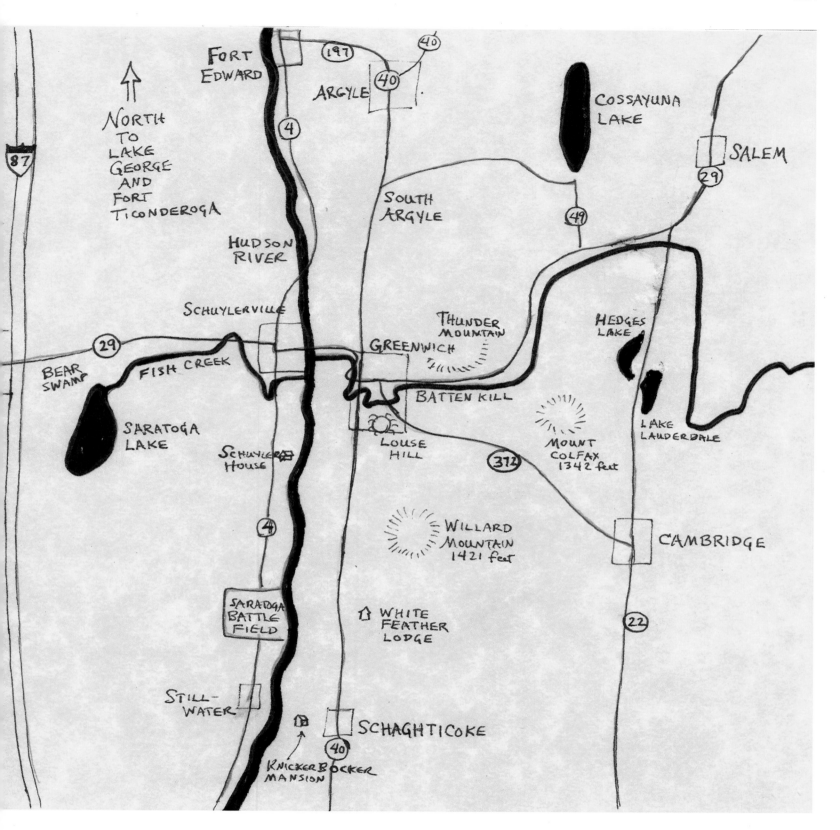

this house is of considerably more questionable origin. There is no Knickerbocker line in Holland. The founder of the dynasty, Hermen Jansen, usually gave his last name as van Bommel, signifying that he came from Den Bommel, in North Brabant. In one document, a contract with Anthony van Schaick, in 1682, he signed his name "van Wyekcbacke." How he came by that moniker and how it became Knickerbacker remain a matter of speculation. Wherever it came from, "Knickerbacker" appears on all the old stones in the estate's cemetery.

It took the mischievous wit of Washington Irving to work the final transformation of the name. Visiting his friends among the old Dutch families of the Hudson Valley, Irving appropriated the most colorful name he could find and changed the *a* to an *o*. Then, he apparently seized upon the name of Derrick, one of the Knickerbacker nephews, and modified it to Diedrich. Thus was born the cranky old gentleman who narrates Irving's humorous book, *Knickerbocker's History of New York*. The imaginary Diedrich Knickerbocker became so famous that the family

Lake George
2007; gouache on canvas;
9 x 12 in.

The most impressive aspect of Lake George is the range of rounded mountains and hills that run north and south along its banks. Driving north on Route 9 offers a wealth of places to see and things to do: Lake George Village, lake front views, vintage boats, Adirondack furniture, and the famous Mohican boat ride that takes its guests out into the middle of the lake for a completely different view of the mountains.

gave up on the older spelling and adopted the newer one. The youngest obelisk in the graveyard bears the new spelling; even in death, life imitates art.

Jon Stevens offered to show us the cemetery. The air was heavy with field scent and the moisture of a late summer afternoon as we walked between the walnut trees toward the graveyard wall. A frog jumped into the ditch by the roadside,

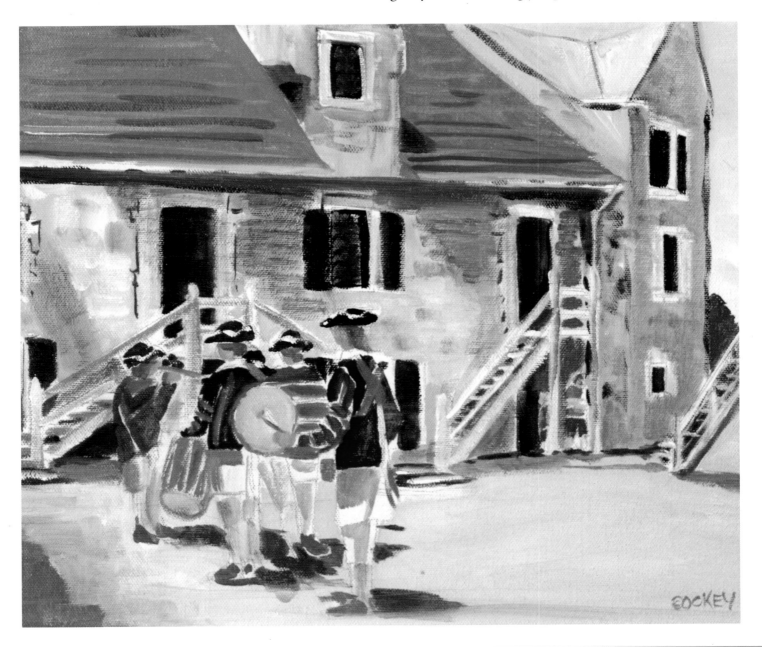

and crickets sang in the tall grass. Leaning toward the house that he built was the marble headstone of John Knickerbacker. This was one of those brooding, sleepy, summer afternoons so typical of the area, with a faint, distant rumble of thunder, a *Rip Van Winkle* day. Washington Irving, who knew some of the residents of this graveyard, would recognize his old stomping ground.

Reading *Knickerbocker's History of New York*, it is easy to see why New Yorkers made the name their own, even naming a team after it. The early Dutch settlers are depicted as quaint, rotund, pipe-smoking burghers who ate, drank, and slept their way across the Atlantic:

> Their craft was made by the ablest ship-carpenters of Amsterdam, who, it is well known, always model their ships after the fair forms of their country-women. Accordingly, it had one hundred feet in the beam, one hundred feet in the keel, and one hundred feet from the bottom of the sternpost to the taffrail. Like the beauteous model, who was declared to be the greatest belle in Amsterdam, it was full in the bows, with a pair of enormous catheads, a copper bottom, and withal a most prodigious poop.[3]

They got along with the Indians either by scaring them away with the sound of their Low-Country language or by following their natural inclinations:

> The Indians were much given to long talks, and the Dutch to long silence: in this particular, therefore, they accommodated each other completely. The chiefs would make long speeches about the big bull, the wabash, and the Great Spirit, to which the others

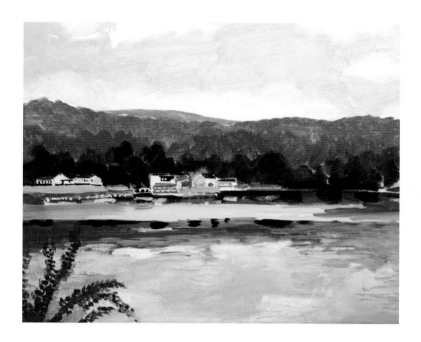

Cosayunna Lake
2007; gouache on canvas;
9 x 12 in.

Cosayunna is tucked into the countryside, lying somewhere between the towns of Argyle, Salem, and Greenwich. It was a favorite destination for many local residents during the hottest part of the year. Today there are still many summer camps and year-round residences around the lake.

would listen very attentively, smoke their pipes, and grunt yah, myn-her; whereat the poor savages were wondrously delighted. They instructed the new settlers in the best art of curing and smoking tobacco, while the latter in return, made them drunk with true Hollands, and then taught them the art of making bargains.[4]

These portly people, with their peculiar names and quaint ways, beguiled the reading public. Like a boatload of Homer Simpsons in Dutch breeches, the bumbling, irascible, cheating, over-stuffed burghers of Nieuw Nederlandts are Everyman. They caught the popular imagination, and New Yorkers have been Knickerbockers ever since.

LAKE GEORGE

The first white man to set eyes on Lake George was the Jesuit missionary Father Isaac Jogues, who was firmly dedicated to spreading the Gospel. He was so struck by the beauty of the lake that he named it Lac du Saint Sacrement. Jogues was cap-

Fort Ticonderoga
2007; gouache on canvas;
11 x 14 in.

Fort Ti is positioned on the southernmost tip of Lake Champlain. Today, however, there is a large swamp-like area between the fort and the lake. According to history, the fort changed hands several times, but nary a shot was fired in the taking and retaking of the fort, first by General John Burgoyne and then by Ethan Allen and the Green Mountain Boys. The day we visited was bright and sunny, and there was a lot to see and do. Shown here are a fife and drum ensemble that put on a wonderful show. Oh yes, don't forget to go through the exhibits!

tured and tortured by the Mohawks, survived, and lived among them as an adopted member of the tribe. After being ransomed by a Dutch trader, he returned to France. His hands were so mangled by torture that he had to obtain special dispensation to give Communion. Against the better advice of his friends, he returned with the hope that the Mohawk Indians were now ready to receive the Word and appeared before his new flock in his priestly, black cassock. They thought he looked like a sorcerer and accordingly brained him with a tomahawk and cut off his head.

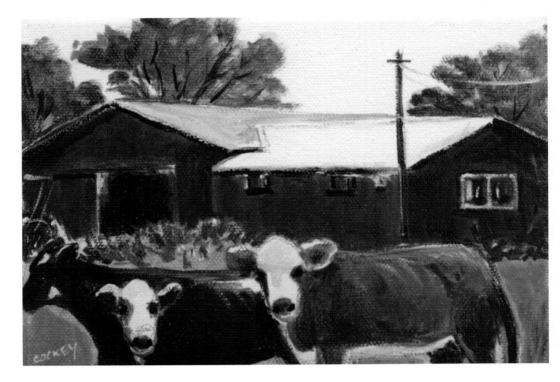

These days, activities on the lake are of a lighter nature. During the summer months, the shore road is typically busy, and the motels and guest houses usually are packed. The lake shore accommodations range from little cottages with beat-up canoes to grand estates with boat houses full of canopied, antique motor launches and mahogany speedboats. The brilliant, blue waters and mountainous banks are reminiscent of Lake Geneva. A steamboat completes the picture.

The lake formed along faults in the earth's crust, the north-south orientation tracing the course of the nearly vertical faults on each side, which allowed a long, central block to drop down more than twelve hundred feet. Unlike active faults such as the San Andreas in California, these eastern Adirondack faults have not moved since the Middle Ordovician, some 450 million years ago. Broken rock erodes faster than sound rock, and thus water scoured out the floor of the lake valley. Then the great period of glaciers began about 1.6 million years ago, and ice continued the process of slowly grinding away the rocks. Several different ice sheets scraped their way across this landscape during the Pleistocene Epoch, repeatedly rearranging the features of the land. The most recent ice sheet reached its maximal southerly advance only twenty to twenty-five thousand years ago, leaving a pile of crushed stone just north of

Calling the Cows
2007; gouache on canvas;
5 x 7 in.

When I visited my farming friends, Glen and Jessica Townsend, they called the cows over so that I could photograph them for the painting I was going to do. They whistled and bayed at the cows that were grazing just outside the barn, and sure enough, the cows moseyed over to meet us by the fence. And then the cows waited there expectantly. Puzzled, I asked, "What do they want?" Glen smiled before answering. "A treat, of course." And that is the picture I painted, of the cows waiting for their treats.

Glens Falls. Scars on the high peaks of the Adirondacks show that this ice was up to a mile thick. This massive glacier melted away only twelve thousand years ago. It is astonishing that such dramatic freezing and thawing took place so recently, a mere moment ago in geologic time.

ARGYLE AND FORT EDWARD

The Town of Argyle is still mostly rural, with small villages and beautiful old houses scattered through the landscape. The settlers of this region were Scottish families who came over between 1738 and 1740, led by Captain Laughlin Campbell. The British government desired to place the pugnacious Highlanders in upper New York as a buffer against the French. Greedy officials in the New York government delayed the impoverished Scots with demands for fees and self-serving

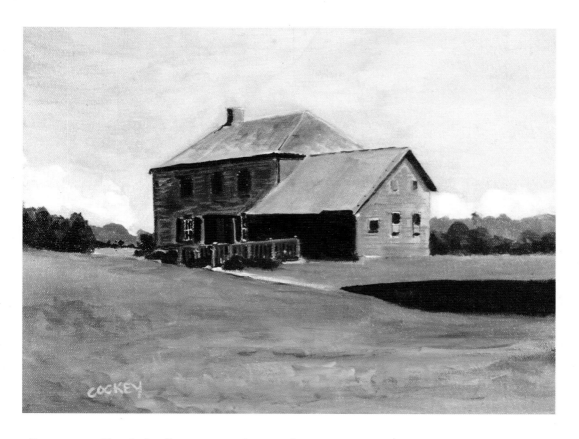

Knickerbocker Mansion
2007; gouache on canvas;
11 x 14 in.

The Knickerbocker Mansion is located just north of Mechanicville, on the east side of the Hudson River. It's a short trip from Greenwich, Easton, or Stillwater if you've got time for a ride. To get there you have to pay close attention and turn off Route 67 onto a country road (Knickerbocker Road) that will take you through several cornfields before you arrive in front of the mansion. I was sad to learn the oak trees that lined the perimeter back in the late 1700s would never be planted again. Too many deer, they said.

allocations of land, finally granting the Argyle patent in 1764. The twenty-four-year delay took its toll. Many of those who had crossed the Atlantic with the expectation of settling here had either died or gone elsewhere.

As a result of their strained relations with the New York provincial government, the citizens of Argyle were not immediately enthusiastic about the American Revolution. In August of 1775, when all men between sixteen and sixty were summoned to enroll in the militia, very few came forward from Argyle. Their attitude changed two years later, though, after Burgoyne's Indian allies came through Argyle and massacred the Allen family and murdered Jane McCrea, as described in the chapter on Easton. Some residue of the stern Scottish Calvinist outlook prevails to this day; Argyle has the distinction of being one of the very few dry Towns in the state of New York.

Knickerbocker Cemetery
2007; watercolor;
16 x 20 in.

Our cousin Jon mows the lawn carefully around gravestones that date from the mid-1700s and that have slid to one side or fallen over. As we walked around the cemetery, he told stories about some of the people buried there: wild and enchanting tales that kept our rapt attention and interest. Don't be afraid to visit the graveyard; surrounded by a four-foot stone wall in the middle of gentle rolling hills and woodlands, it's about as serene as it gets.

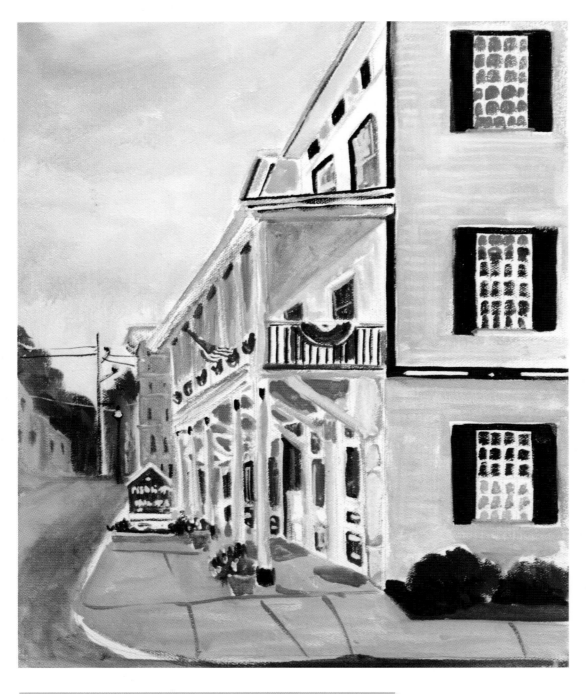

Ballston Spa
2007; gouache on canvas;
11 x 14 in.

Medbery Inn & Spa sits on a prominent corner in the heart of downtown Ballston Spa. The movie, The Way We Were, featuring Robert Redford and Barbra Streisand, was filmed there back in the early 1970s. Aside from that interesting detail, the community boasts numerous historic buildings, antique and collectibles shops, and several great restaurants and pubs. It's not far south from Saratoga Springs, off Route 67. I love to spend lazy afternoons there, eating and browsing for stuff that you just can't find someplace else.

miles to the West is Fort Edward, where families from Argyle took refuge after the massacres.

The fort is long gone and was actually scavenged for building materials after the French and Indian War and, as a result, was of no value as a defensive position against the British as General Schuyler's forces retreated toward Saratoga.

The original strategic importance of Fort Edward lay in its location at the falls of the Hudson, which forced travelers to carry their canoes overland to Lake Champlain. The Indians called it Wahcoloosencoochaleva, meaning "great carrying place." It is now called Fort Edward because no one could pronounce the Indian name. The first stockade was erected here in 1709 and called Fort Nicholson after Sir Francis Nicholson (1655–1727), the British military officer who directed the building of it; and herein lies a Maryland connection. This was the same man who served as governor of Maryland from 1694–1699 and moved the capital of the Maryland colony from St. Mary's City to Anne Arundel Town, thereafter called Annapolis. He was evidently gubernatorial material, as he was also at various times governor of New York (1687–1689), Virginia, Nova Scotia, and South Carolina.

Today the Champlain Canal connects the Hudson River to Lake Champlain, and the drive down Route 4 toward Schuylerville provides pleasant views of the Hudson and of the canal with its locks. The confluence of the canal and the Hudson at Fort Miller presents a particularly interesting sight, with the level water of the canal running off southwest while the river pours over dams to the East. Also along Route 4 is a marker at the place where Jane McCrea was initially buried.

Route 40 runs north from Greenwich through Argyle Village and into rolling farmland. Tree-covered mountains rise in the distance. Whenever we pass this way, we both are struck by the similarity to Texas, but this hill country is much greener. A few

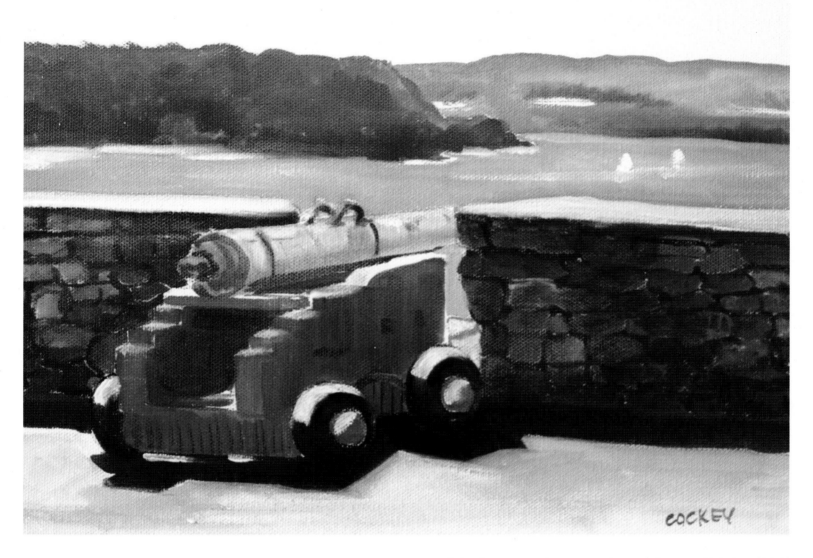

COCKEY

This spot is very close to where she was killed. Her remains have since been moved, first to the village cemetery at Fort Edward and later to Union Cemetery.

Route 4 continues southward along the line of Burgoyne's march and leads out onto the main street of Schuylerville. Up the hill to the right is the Saratoga battle monument, and down the hill on Route 29 toward the Hudson lies the historic field where Burgoyne's men stacked their arms.

FORT TICONDEROGA

"In the name of the Great Jehovah and the Continental Congress!" According to legend, this claim of transcendent authority by Ethan Allen (along with the element of surprise, a force of eighty-three tough backwoodsmen, and the advantage of dry gunpowder) was the price of admission here in the early morning darkness of May 10, 1775. At noon on August

Overlooking Lake Champlain
2007; gouache on canvas;
9 x 12 in.

The cannon is a part of Ft. Ticonderoga's authentic collections: artillery, clothing, paintings, and utensils that were used as far back as the French and Indian War. It rests today in a portion of the gunnery wall of the fort and overlooks Lake Champlain. When we visited, there were tiny sailboats on the lake, and it was peaceful. All was well.

8, 2007, tickets were twelve dollars and well worth the money. The view alone was magnificent, across the narrows of the lake, down the South Bay of Champlain, and over the wetlands along the beginning of the La Chute River, aptly named, as it falls 230 feet over its 3½ -mile course to Lake George.

The intensity of human conflict at this strategic pinch point at the portage between Lake Champlain and Lake George lends a darker depth of coloration to the scenery. These trees

and lawns are fed by the blood and bones of thousands of soldiers who perished to gain this little spot of ground. The name Ticonderoga, which is Indian for "land between two waters," implies the great military significance of the site. Anyone traveling north or south between Lake George and Lake Champlain had to carry his boats overland here to avoid the falls.

We last left Sir William Johnson's military exploits in the Saratoga chapter with his victory over the French at Lake George and the wounding and capture of Baron Dieskau, who commanded the French forces. Rather than press northward to take Fort Saint Frédéric, Johnson stayed where he was and built Fort William Henry. The French then decided to construct a fort on Ticonderoga Point as a barrier to possible future British incursions toward the aging Fort Saint Frédéric at Crown Point, which had been completed in 1737 and was the nidus of a French farming settlement of several hundred people.

When the French builders, led by the Marquis de Lothbinière, arrived here in October of 1755, the site was covered by forest, which proved to be as much of an impediment as the graft and corruption that plagued the enterprise. After a year of work, the fort was still unfinished, but enough trees had been cut down to reveal the actual position of the bastions in relation to the waterway. Merde! One saw avec chagrin that one had made un erreur most malheureux. The fort was in the wrong place, too far from the narrows to be effective! Knowing that the British would not wait much longer before renewing their attack, the builders hastily erected a smaller redoubt where the fort should have been. By the time the bitter winter weather shut down their activities, the new year of 1757 found a still-unfinished complex of earth and logs, with a battery of thirty-six cannon. Its name was Fort Carillon.

In April of 1757, the Marquis de Montcalm took the offensive and advanced southward in the action immortalized in James Fenimore Cooper's *The Last of the Mohicans*, destroying Fort William Henry and quite likely conniving in the dastardly slaughter of the retreating British after the surrender. The fact that the ambush was the work of the Indians continues to lend the Marquis plausible deniability of responsibility. The English were certainly not amused, and in July 1758, General James Abercrombie led a huge army of thirteen thousand combined British and colonial troops toward Fort Saint Frédéric. The crafty Montcalm, outnumbered almost four-to-one, fortified a hill west of Fort Carillon with a breastwork of earth, logs, brush, and sharpened stakes. Against this deadly abatis, Abercrombie ordered a series of infantry charges. Over nineteen hundred of his men perished in the fruitless assault. A third of the dead were the bold, kilted Highlanders of the Forty-second Foot, also called the Black Watch Regiment.

The next year, General Jeffrey Amherst led another expedition against Carillon. The French withstood the siege for four days and then withdrew, setting a match to the powder magazine on the way out. The Brits repaired the fort, captured and refortified Crown Point, and planted warships on Lake Champlain. But for their determination, we might be asking for directions in French today.

By the time Ethan Allen and Benedict Arnold arrived at Ticonderoga, the place was a mess. Beginning with a structure of dirt and logs, the fungi and insects of New York had reduced the fort to dirt and rotten logs. The bored soldiers had neglected to keep their powder dry and had not received word of the rebellion in the colonies. When the sun rose and the Green Mountain Boys looked out toward Lake Champlain, a nearly treeless landscape met their gaze. After twenty years of military activity, all the timber within easy reach had gone to fuel fires and to build barricades. The view was pleasing nonetheless, if slightly blurry, as all the conquerors except Arnold were celebrating by drinking ninety gallons of rum liberated from the personal stock of the fort's commandant, Captain William Delaplace. Allen gave Delaplace a receipt for the rum that was later paid in full by the State of Connecticut.[5]

The next day, Seth Warner and his men took Crown Point, which, having burned down a year earlier, was in an even worse state than Ticonderoga. Arnold went to work with his characteristic energy, improving Fort Ticonderoga and building a floating bridge across the lake to Mount Independence, where he built another fortification. In December, General Henry Knox managed the seemingly impossible feat of boating, dragging, and sledding cannon from the fort to Boston, a three-hundred-mile trip with sixty tons of artillery in less than two months, allowing General Washington to drive the British out of Boston Harbor. Actually, most of the cannon hauled to Boston came from the charred wreckage of Crown Point,

farther to the North. There were two objectives here: relieving Boston and creating a barrier to any British advance from Canada. In this strategic context, it made no sense to remove all of the cannon from Ticonderoga, which the Continental Army still needed as a barrier to invasion by the British.

When one looks across the water to the towering Mount Defiance, it is easy to see why no one imagined that Burgoyne would be able to haul cannon to the top and, to the embarrassment of General Schuyler, force the Americans to abandon the fort. But the bloodless recapture of Ticonderoga on July 5, 1777, proved to be only a prelude to the utter defeat of Burgoyne's forces at Saratoga three months later; and on October 8, the British did what the French had done before them. They burned the fort and withdrew to Canada. But unlike the French, they did leave behind a fleet on Lake Champlain.

Thanks to the foresight and generosity of the Pell family, the ruined fort has been restored and has never been cleaner. The trees have grown back, and the gunfire is for demonstration purposes only. The museum has an extraordinary display of the material culture of the 1700s. Even the cannon are back! Ticonderoga has the best collection of eighteenth-century artillery in North America, a must-see.

CONCLUSION

Visiting upstate New York is a homecoming. For Elizabeth, it is a reconnection with family and childhood friends and the beloved places of her younger days. For me, it is a marvelous new connection with dear people who are so friendly that I feel as if I, too, have known them all my life. But beyond these immediate personal relationships, there is the romance of stepping back into the past, an act that is sometimes as easy as walking down a street that has scarcely changed in a hundred years and sometimes as difficult as picturing wild Mohawks in Saratoga Springs, a French army at Ticonderoga, or stone-age men hunting woolly mammoths along the edge of Lake Champlain. Add to these attractions the beauty of the hummocky hills, the brilliant fall foliage, the crystal waters, and miles upon miles of farm country, and the place is irresistible.

(Endnotes)

[1] Tefft, *The Story of Union Village*, 63.

[2] Ps 91:4–5.

[3] Irving, *Knickerbocker's History of New York*, 51.

[4] Irving, *Knickerbocker's History of New York*, 54.

[5] Davis, "In the Name of the Great Jehovah and the Continental Congress!"

ACKNOWLEDGMENTS

Early on in the process of writing this verbal frame for Elizabeth's paintings, I realized that if I made up this stuff, someone would notice. Then it came to me that even if I tried really hard to get every detail right, there might be some horrendous faux pas that would have everyone up in arms. Maybe there still is. If so, the fault is entirely mine and not Elizabeth's. Fortunately, I have had the benefit of the learned criticism of Tim Tefft and Jon Stevens, whose knowledge of this blessed spot is nearly encyclopedic. I am also very grateful to Bob Wright and George Perkins for showing me the sights and sharing their rich store of local history. My thanks go also to Jack Barber and Charlie Tracy for their contributions to this effort. We both offer our thanks to the team at BookPros. Their support and encouragement, skill, and energy made the process of creating this book a joy. Special thanks also to Ken Kinard, web designer, photographer, and computer genius extraordinaire.

BIBLIOGRAPHY

Andrews-Hoag, Helen. *A Walk in the Village: Through the Greenwich Village Historic District.* Glenns Falls, NY: Coneco Litho Graphics, 1997.

Davis, Kenneth S. "In the Name of the Great Jehovah and the Continental Congress!" *American Heritage Magazine* 14, no. 6 (October 1963). http://www.americanheritage.com/ articles/magazine/ah/1963/6/1963_6_65.shtml.

Horne, Field. *Saratoga Springs: The Complete Visitor's Guide.* Saratoga Springs, NY: Kiskatom Publishing Company, 2007.

Houghton, Raymond C. *A Revolutionary War Road Trip on U.S. Route 4.* Delmar, NY: CyberHaus, 2004.

Irving, Washington. *Knickerbocker's History of New York.* New York: American Book Exchange, 1881.

Katz, Jon. *The Dogs of Bedlam Farm.* New York: Villard Books, 2004.

Kirkwood, Robert. *Through So Many Dangers: The Memoirs and Adventures of Robert Kirk, Late of the Royal Highland Regiment.* Edited by Ian McCulloch and Timothy Todish. New York: Purple Mountain Press, Ltd., 2004.

McIntosh, Robert G., 2007. *The Covered Bridges of Washington County.* Cambridge, N.Y., A&M Printers.

Niles, Grace Greylock. *The Hoosac Valley: Its Legends and its History.* Bowie, MD: Heritage Books Inc., 1997. First published 1912 by G.P. Putnams's Sons.

Riedesel, Friederike Charlotte L. *Letters and Journals Relating to the War of American Independence and the Capture of the German Troops at Saratoga.* Translated from German. Chapel Hill: UP of NC, 1965.

Tefft, Grant J. *The Story of Union Village.* Greenwich, NY: Greenwich Journal, 1942.

Tefft, Tim. *A Season of Terror.* Greenwich, NY: Greenwich Journal, 2002.

Tefft, Tim and Richard S. Tefft. *Chapters in the History of Greenwich.* Greenwich, NY: Greenwich Journal and Salem Press, 2003.

Van Diver, Bradford B. *Roadside Geology of New York.* Missoula, MT: Mountain Press, 1985.

Waller, George. *Saratoga: Saga of an Impious Era.* Gansevoort, NY: private printing, 1966.

Washington County Planning Board. *An Introduction to Historic Resources in Washington County, New York.* Granville, N.Y: Grastorf Press, Inc., 1976.

INDEX

Over the River and Through the Woods
(Back cover)
2007; watercolor;
16 x 20 in.

My grandmother made every holiday come alive through her recipes and sit-down meals where sometimes fifteen or twenty family members crowded around the dinner table. She never let any of us eat until everyone had assembled; it was important that we gather and eat together as a family, she told us. My parents would drive over to my grandparent's house in all kinds of weather, over the Battenkill River or sometimes across the farm and through the woods. And it was good, it was all very good.